THE
MOSAIC
IDEA BOOK

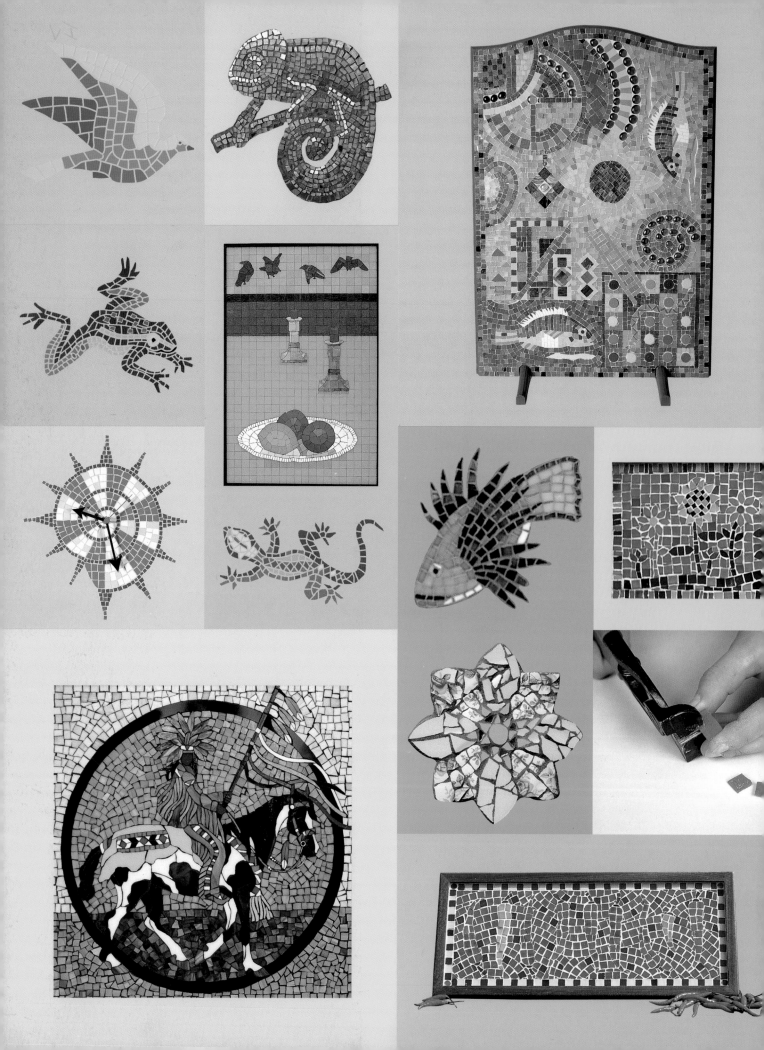

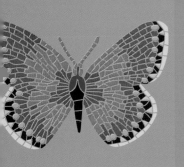

THE
MOSAIC
IDEA BOOK

More than 100 designs to copy and create

ROSALIND WATES

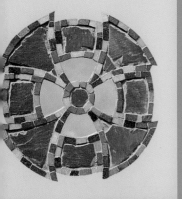

NORTH LIGHT BOOKS
Cincinnati, Ohio

A QUARTO BOOK

First published in North America
in 2000 by North Light Books,
an imprint of F&W Publications, Inc.
4700 East Galbraith Road
Cincinnati, OH 45236
1-800/289-0963

Copyright © 2000, 2002 Quarto Inc

Reprinted in 2002

ISBN 1-58180-095-9

QUAR.MOSD

Conceived, designed, and produced by
Quarto Publishing plc
The Old Brewery
6 Blundell Street
London
N7 9BH

Editor Kate Michell
Art Editor Sally Bond
Assistant Art Director Penny Cobb
Text Editors Claire Waite, Neil Cole
Designers Jenni Dooge, Karin Skånberg
Illustrator Jenni Dooge
Photographers Martin Norris, Paul Forrester
Picture researcher Laurent Boubounelle
Indexer Ann Barratt

Art Director Moira Clinch
Publisher Piers Spence

Manufactured in China by
Regent Publishing Services, Ltd
Printed in China by Leefung-Asco Printers

CONTENTS

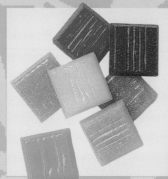

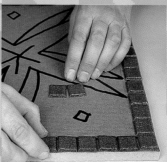

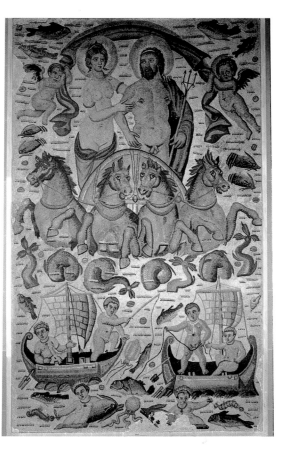

INTRODUCTION

Mosaic is a popular form of decoration and expression, and, more than ever, an art that is accessible to everybody. This book aims to provide ideas and inspiration to mosaicists of all abilities. But first, a brief journey through mosaic's past provides an excellent foundation from which you can create your own work.

The historical roots of mosaic are spread in many directions. Earliest examples include mosaic-covered Sumerian pillars using clay "pegs," and artifacts such as harps and chests encrusted with lapis lazuli, gold, and mother of pearl. The ancient Egyptians and pre-Columbian cultures—like the Aztecs and Maya—also inlaid furniture and decorative items with precious materials to wonderful effect.

Early Greek mosaics consisted of uncut pebbles and simple geometric patterns, but by the fourth century B.C. pebble mosaics had become more sophisticated, with greater use of color and strips of lead or copper delineating areas of particular importance. Around this time, mosaic materials started to be cut and shaped into "true" tesserae, or cubes—pieces that could be set closely together, encouraging greater detail and refinement.

It was the Romans who, inheriting the medium from the Greeks, carried mosaic to its first great flowering. They used mosaics to embellish public buildings and the homes of the wealthy. Tesserae were cut from marble, stone, fired clay, and, occasionally, glass. Mosaics of great sophistication showed scenes from mythology, the theater, hunting parties, and detailed society portraits. Often they were based on paintings, aiming for a certain degree of realism and using a wide range of colors. Micromosaics, made from minute tesserae, were popular and portable.

At the opposite end of the spectrum were mosaics using just two or three colors, often black and white, that translated themes in a more two-dimensional way; realism was not regarded as important, rather the focus was on depicting the essential character and energy of the subject.

As Christianity spread through the Roman Empire during the fourth century A.D., important developments took place in mosaic technology. Advances were made in the production of glass and

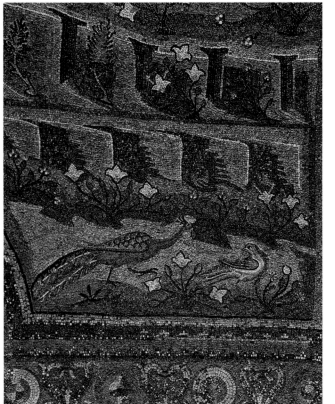

Below This mosaic found in Ravenna, Italy dates from the sixth century. Made from gold and brightly colored glass smalti, it shows popular motifs of the time: birds, flowers, and foliage.

gold tesserae. A vast array of colors became available, and glass tesserae began to replace stone and marble.

The Byzantine Empire is regarded as the era of the second great flowering of mosaic. The emphasis at this time was on religious instruction. Symbolism became important: vast areas of gold tiles represented the other-worldliness of heaven, imperial purple was used for the robes of Christ. Although the gentle hues of natural stone were still used for faces and hands, the mosaics took full advantage of the much wider and brighter range of colors newly available in glass.

Below Mosaic is an ideal medium for tough, vandal-proof art in public spaces. In this example, colorful motifs illustrate a mosaic map of Coventry Canal Basin.

During the Renaissance, artists began to rediscover perspective and realism, and painterly skills and draftsmanship took precedence—mosaic was valued merely as a way of reproducing great paintings. By the nineteenth century, mosaic was popular for decorating public buildings, but still there was

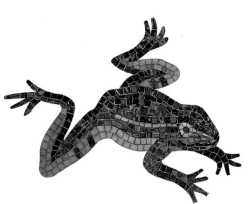

Above The extensive range of colors that mosaic tiles are available in allow realistic depictions of all manner of things, particularly animals and birds.

little innovation to be found until the close of the nineteenth century and the first few years of the twentieth century, when mosaic was affected by the revolutionary ideas prevalent in art at the time. Mosaic once more became a creative medium, resulting in an explosion of dynamic and exciting new mosaic art, which has carried through to the twenty-first century.

This brief historical journey is intended to show present-day mosaicists a glimpse of their heritage. Take note of the past, but be inspired by the many different motifs in this book to produce your own bit of history.

In this book you will find advice on mosaic construction, design, and use of color, as well as many ideas for motifs and images to inspire you. You can browse through it for ideas and inspiration, or select a particular motif or color scheme to try out for yourself: the templates can be traced or photocopied for your own use. The colors used are matched to commonly available ranges of vitreous and unglazed ceramic tesserae.

I hope that this book gives you confidence and helps you make beautiful mosaics; but I also hope that one day you will close the book, and let your imagination soar.

MOSAICS:
THE BASICS

Getting started on making your own mosaic can be a daunting business. This section provides basic information to give you the confidence to put tile to board and create your own unique work of art. Materials, equipment, and techniques are covered, as well as advice on color and design. The visual techniques will help you to develop your understanding of the mosaic medium and, although traditional, they should also allow you to feel free to experiment and explore your own ideas to the full.

SETTING UP

The things you need to consider before you start on your mosaic include your base, your selection of tesserae, your chosen adhesive and grout, and a suitable working area. The more you can organize yourself in advance, the more relaxed and creative your mosaic making will be. Each project has its own particular requirements, and these have to be considered afresh; for example, are the materials you are hoping to use suitable for the location of the mosaic?

Ceramic tesserae

Surfaces

Almost any surface can provide a base for a mosaic, as long as it is stable, dry, and free from grease.

Shiny surfaces, such as metal or ceramic, need to be rubbed down with coarse-grade sandpaper or steel wool to provide a key. A floor will need a smooth sand and cement screed, free from lumps and bumps. The easiest surface to work on is wood, in the form of plywood or fiberboard (M.D.F.). If your mosaic is going outside, use exterior or marine ply, although any wooden base risks being affected by damp eventually. For inside siting, any solid wooden surface is suitable. Glass can also be used as a base, with the aid of special glass glues now available.

A long-lasting exterior solution is to place an indirect mosaic (see The Direct and Indirect Methods, page 14) paper-side down in a frame held together with screws. Back the mosaic with reinforcing mesh sandwiched between two layers of mortar (one part cement to three parts sand). When the mortar is dry you can unscrew the frame and release the mosaic slab.

▼▶ Ceramic tesserae are usually ¾–1-inch (20–25-mm) square and are available glazed or unglazed. The unglazed range features a limited but wonderfully earthy palette of colors that relates closely to the colors of many Roman mosaics. They are inexpensive and can be used just about anywhere.

Glazed tiles have a thin, brittle layer of glaze that, when cut, creates sharp, rough edges that expose fragments of the clay underneath, even after grouting. Because they also have rounded edges, the gaps between the tesserae fill up with a lot of grout, resulting in the appearance of more grout and less tile than you might have expected. However, they are inexpensive and open up their own range of amazing visual possibilities. They are not suitable for floors, and may not be frostproof.

Ceramic tesserae

Tesserae

A piece used in a mosaic is called a "tessera" ("tesserae" in the plural), from the Latin word for cube, although the tiles used today are generally not cubes. Your first consideration when choosing tesserae must be a practical one—make sure they are suitable for the conditions the mosaic is going to exist in: frostproof, or strong enough to be walked on, for example.

Some tesserae are bought in loose form, others are glued to sheets of brown paper that can be soaked off in hot water and a little dishwashing detergent: rinse them well before laying them out to dry. Be wary of buying tesserae attached with blobs of rubberlike adhesive: you will have to snip them apart with scissors which can be a real nuisance.

▼ Vitreous glass tesserae are usually ¾-inch (20-mm) square, with a flat upper surface and beveled underneath. They are available in a relatively wide range of colors, including some exotic shades. The intensely bright colors tend to be dramatically more expensive than the muted, soft, grainy colors that contain more sand. They are good for walls, ceilings, and three-dimensional objects, but not for floors.

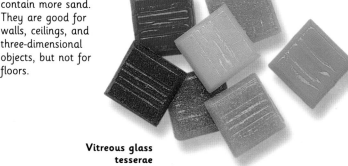

Vitreous glass tesserae

▼ **Smalti** are handmade tesserae from Italy, made of a very dense, enamelized glass and have been used since the Byzantine era. They are mostly opaque and come in an enormous range of colors. They are usually between ⅝–¾ x ⅜ inch (15–20 x 10 mm) in size and have uneven surfaces that can produce a glittering appearance. They are expensive and cover alarmingly little surface area. It is also difficult to achieve a flat surface for floors with smalti.

Marble tesserae

▲ ▶ **Marble** is a wonderful, traditional material with natural color variations, however, it is expensive, and not many colors are available. Marble tesserae are heavy, chunky, and good for floors. You can buy ready-cut tesserae or rods or sticks that you cut down yourself. Highly polished, riven, and honed, matte finishes are available.

Marble sticks

Marble tesserae

Smalti

Pebbles

◀ ▼ ▶ **Other materials**
Collecting bits and pieces—pebbles, shells, buttons, broken china—to use in a mosaic brings out the magpie in all of us. The only check to your imagination is practical suitability.

Seashells

▼ **Gold smalti** are sumptuous tesserae that consist of gold or white gold between two layers of glass: one thick to provide a strong base, and one very thin to protect the gold on top. Some have a textured, rippling effect. They are handmade and very costly, but they are also fabulous.

Gold smalti

Buttons and broken china

Adhesives and Grouts

The world of adhesives and grouts is constantly evolving, with new products to suit almost any condition coming onto the market every year. Always read the packet and ask advice at a reputable tile shop to make sure you buy the right product for your particular mosaic.

▼ **Cement** can be mixed with sand and used for installing mosaics indoors and out, and for grouting. It is very alkaline, so wear rubber gloves when working with it. Dyes are available for coloring cement, but experiment with small quantities before committing yourself. Cement needs to be kept damp for a few days to cure.

▶ **Ready-mixed cement-based adhesive** is a standard tile adhesive used for the direct method and to fix an indirect mosaic into its final site (see The Direct and Indirect Methods, page 14). It comes in shades of white and gray, usually as a powder to be mixed with water. Try to match the color of your adhesive as much as possible to the grout you plan to use. Additives that aid water resistance and add plasticity can be mixed in.

▶ **Epoxy adhesive and grout** is available in a variety of shades, and is a powder that needs to be mixed with two liquids. It is extremely strong, but an expensive option. You need to be quick and confident when using it: there is absolutely no going back once a mosaic has been set in place.

▶ **Water-soluble white glue (P.V.A.)** is used neat for gluing tesserae directly onto wooden surfaces for indoor use, although it is not suited to gluing directly onto vertical surfaces: the tiles will slip down before the glue sets. Diluted water-soluble white glue is used to glue tesserae to brown paper for the indirect method (see The Direct and Indirect Methods, page 14).

▶ **Gummed paper** is available for working indirectly (see The Direct and Indirect Methods, page 14). Just wet it before positioning the tesserae.

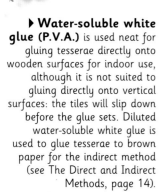

▶ **Ready-mixed grouts** can be bought in powder form in many colors, although the usual shades are white, gray, ivory, and brown or beige. The powders—basically sand mixed with cement—vary in coarseness: fine grains for close-set tesserae, larger grains to fill wider gaps. The powder is mixed with water and an optional additive to add plasticity and make the grout waterproof. Special colors can be mixed into ordinary grout to make up a particular shade.

▶ **Two-part epoxy resin** is useful for extra strong and weatherproof adhesion when working directly onto the base (see The Direct and Indirect Methods, page 14). It is available in quick- or slow-setting versions, but is sticky to use and a fairly expensive option.

The Workshop

If you can, dedicate a particular space as your mosaic workshop, taking into consideration a few necessary requirements.

Good light is essential—plenty of natural daylight and overhead lighting. Try to work with dark tiles during daylight hours, as it can be quite difficult to see the colors properly under artificial light.

Your chair and worktop have to be the right height for you, so that your elbows are not cramped or your shoulders craning over to access the mosaic.

You will need access to water and an outside drain for emptying water that has any amount of adhesive or grout in it: if poured down the sink these will set and eventually damage your drainage pipes.

If your floor is carpeted, lay a plastic sheet over it so debris doesn't sink into the carpet.

Shelves and jars or plastic bags seem to be the best solution for storage. A well-organized workspace will speed your mosaic along and make the work much more enjoyable. Everybody learns to appreciate the benefits of an ordered workshop.

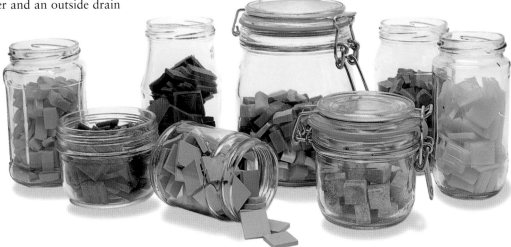

Storage facilities are essential. A collection of recycled jars will store your tesserae efficiently, and will also allow you to see the colors at a glance.

MOSAIC TECHNIQUES

In this section we look at the basic techniques of mosaic, so if you are making a mosaic for the first time, you will find everything you need to know to get started. Some of this will seem obvious, some less so. However, with a little experience you will soon find your own personal way of doing things, and then you can decide which methods work for you and which don't.

Creating the Original Design

To begin with, you will need to produce a full-size design on paper, complete with indications of the colors you are going to use (see Designing Your Own Mosaic, pages 22–25).

Transfer the design onto the base for your mosaic by careful measuring and copying, or using carbon paper. If you are mosaicing a portable board you can attach your design to the base by making a hinge on one side with masking tape. Slip carbon paper underneath and draw firmly over your design. Check your progress by lifting the design and the carbon paper: because of the tape hinge, the design can be laid back down in exactly the same place.

The Direct and Indirect Methods

There are two basic methods for making a mosaic: the direct method and the indirect method. The direct method is the most obvious technique. The tesserae are fixed directly in place onto the base, the right way up, then grouted. It is a one-stop process, and what you see is what you get. This method does not produce smooth, level surfaces, and is unsuitable for floors.

The indirect, or reverse, method involves constructing your mosaic upside down on a sheet of brown paper. This is an interim measure that allows you to work on the mosaic in a comfortable position away from the final site. The indirect method produces a smooth, level surface, particularly useful if your tesserae are of uneven depths.

Direct method

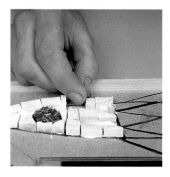

◀ Transfer your design onto the base and apply a little glue and tesserae at a time (see Laying and Gluing Tesserae, page 17).

Indirect method

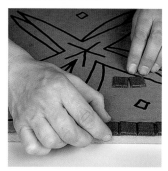

1 Transfer your design, in reverse, to brown paper. Glue the tesserae face down onto the paper using diluted water-soluble white glue (one part glue to one part water).

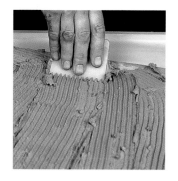

2 Spread a ready-mixed cement-based adhesive over the base of the mosaic's final site, then comb through with an ⅛-inch (3-mm) notched adhesive spreader. Try not to take too long over this: the adhesive can become "tired" and won't behave properly.

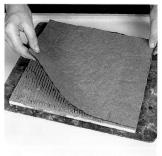

3 Place the papered mosaic carefully onto the bed of adhesive, paper uppermost, and press it down thoroughly, using a small flat board to help.

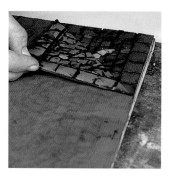

4 Leave the adhesive to set completely, then dampen the paper using a sponge and warm water. After a few minutes, carefully peel the paper off. The exposed mosaic can then be grouted. You may also consider pregrouting the mosaic before it is set into the bed of adhesive (see Grouting, page 17).

Andamento

The most fundamental decisions you will make when designing your mosaic concern the "andamento." This term refers to the way the tesserae flow, the system you select to carry out each area of your design; it is the mosaic equivalent of the brushstroke. The ancient systems used, called opuses, help us understand how mosaics work and the possibilities that are open to us.

▲ **Opus Regulatum** has the tesserae laid out in a regular grid, both horizontally and vertically. It can be rather mechanical, but definitely has its uses.

▶ **Opus Musivum** is opus vermiculatum extended so that the whole area is filled. Shapes are repeatedly contoured around until there are no spaces left. It is a wonderfully dynamic opus, creating a sense of immense flow and energy.

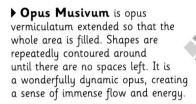

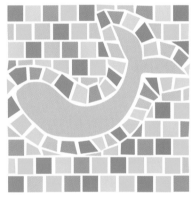

◀ **Opus Vermiculatum** is an outlining technique that gives a shape its own energy and space. The line of tesserae carefully follows a shape, emphasizing the outline. Opus vermiculatum can be used to outline a shape while the remaining area is filled in with opus tessellatum.

▲ **Opus Palladianum** is the "crazy paving" opus: irregular tesserae fit together, the only rule being that the interstices—gaps between the tiles—are the same width. It makes a lively, directionless pattern that adds a sizzle to a mosaic, although used excessively it can be a little tiring to look at.

▼ **Opus Sectile** sits at the boundaries of true mosaic, close to stained glass territory. Each tessera is cut to form a complete shape itself.

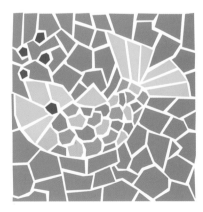

▲ **Opus Tessellatum** uses tesserae to form rows in one direction—either horizontally or vertically—but in the other direction the tesserae are staggered informally. It is important that the tesserae don't match up across the rows, as this will detract from the harmony.

Cutting Tesserae

The quickest way to construct your mosaic is to select tesserae from a pile of ready-cut pieces. Tesserae can be cut using a pair of tile nippers, a fantastic, inexpensive tool with tungsten carbide cutting edges that jut out to one side. The handles are long and kept apart by a spring. The cutting edges don't quite meet when closed.

Always wear eye protection and a face mask when cutting, to guard against splinters and dust that can damage your lungs. The size of tesserae you use is a visual decision only you can make. A quarter of a standard mosaic tile makes a good "base" unit to work with, not too big and not too small. Half units will cover the ground more quickly, but are directional. Eighths, sixteenths, and smaller are versatile but quite fiddly.

tile nippers

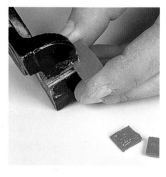

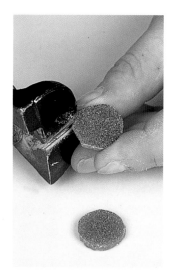

1 Hold the tile nippers in your main hand with the cutting edges facing your other hand. Grasp the handles near the ends for optimum cutting strength. To cut the tessera in half, hold it in your other hand firmly and evenly along one edge. Place ⅛–¼ inch (4–6 mm) of the opposite edge of the tessera into the jaws of the tile nippers. Squeeze the handles to make the cut. It does take a little practice, and even when you are experienced some tiles just won't cut how you want them to. Some vitreous glass tesserae have a slight grain in them; they will cut more reliably across the grain than along it. Each half can be cut in half again, and so on, until you have the size you want.

2 You can also nibble the corners off tesserae to make circles or other special shapes.

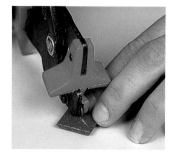

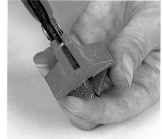

3 To cut small, right-angled triangles, snip the corners off a few tesserae: you are bound to find something useful in the resulting collection. For corner to corner cutting, experiment with a pair of glasscutters, firmly scoring the tessera then snapping it. To cut small wedges, useful for building curves, make two cuts at opposing angles to the edges of half a tessera.

Hammer and Hardie

The traditional way of cutting tesserae, using a hammer and hardie, is particularly suited to cutting marble and smalti. The hardie is a chisel-like blade set into a block of wood or concrete. The hammer has pointed ends.

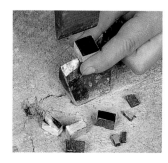

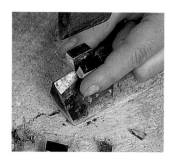

◀ Hold the tessera over the hardie blade at the angle you want it to break at, then bring the hammer down to crack the tessera.

Laying and Gluing Tesserae

It is a good idea to experiment with laying the tesserae before you fix them with glue. First of all, spread your cut pieces out in front of you so you can see exactly what you have to work with. Work on the main subject and border before the background. It's also a good idea to start in a corner and work out from it: corner pieces are often a peculiar shape, and it is easier to adjust the size of one of the more straightforward middle tesserae when fitting the last piece in a line. At this point you also need to work out what sits in front of what to express perspective.

Don't lay too many pieces at a time before gluing them—perhaps glue every five or six pieces—since you may forget exactly what you have glued and what you haven't, and because your unglued work is vulnerable to the slightest movement.

Remember to leave gaps between your tesserae if you are going to grout your mosaic. How wide they are is up to you.

There are two methods of gluing to consider. The first consists of buttering the back of each tessera and then putting it in place. This is slow, but very useful if you are working on a complex area of mosaic. The second is to brush glue onto an area the size of five to six pieces and press the tesserae into place, one by one.

You can use any of the glues featured in Adhesives and Grouts (see page 12), but make sure it is suitable for your particular project. Whichever glue you use, keep an eye on the tesserae for a few minutes immediately after sticking them down; they have a tendency to drift a little.

Gluing

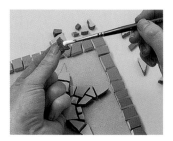

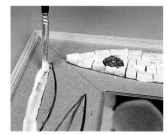

▲ Butter the back of each tessera, piece by piece, as you place them down.

▲ Brush some glue directly onto the board before placing your tesserae down. Remember not to glue too large an area at a time.

Grouting

There is both a practical and an aesthetic reason for grouting. Grout seals the gaps between the tesserae, and makes a strong, impenetrable surface that keeps out weather, dirt, and vandals. The adhesive holds the tesserae from the back, but the grout firmly locks it in from the sides. Grout also makes sense of your mosaic visually, setting off the individual tesserae and showing up the pattern they form. However, if there is no practical reason for grouting your mosaic then you may decide not to for aesthetic reasons.

Grouting

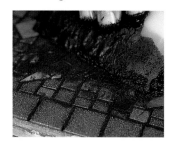

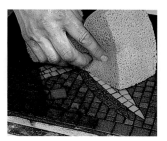

▲ Mix grout powder with water to a mudlike consistency: not too sloppy and not too stiff to stir. Press plenty of grout into the joints using a grout spreader, working in several directions. Clean the grout off the surface with a damp sponge, rinsing it out frequently.

Pre-grouting

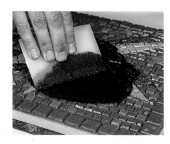

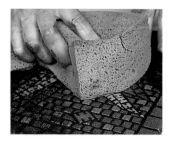

▲ You may consider pre-grouting an indirect mosaic (see The Direct and Indirect Methods, page 14). This avoids the problem of adhesive sticking up between the tesserae. Grout your mosaic from the back while it is still on the paper, quickly wiping the surface and leaving the grout in the joints. Then install and grout as usual.

▶ **Buffing** If your mosaic dries with a dusty-looking film over it, buff it with a dry cloth to leave it bright and clean. Give your completed mosaic a final going over, scraping out odd corners, cleaning any bits of glue left on the surface, and making sure that every bit of it is polished and clean.

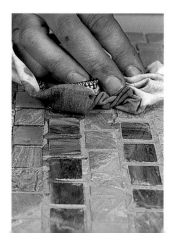

WORKING WITH COLOR

Choosing a color scheme is one of the most exciting aspects of making a mosaic. Balancing a composition and building the scheme is a deeply fascinating process. Sometimes it comes naturally, at other times it becomes a difficult struggle, with indecision and uncertainty dogging every step.

Mosaic is a one-way process and difficult to undo, so it is a good idea to work out your main color choices before you start work. You want, as far as possible, to get it right first time. However, don't be afraid to make one or two decisions along the way.

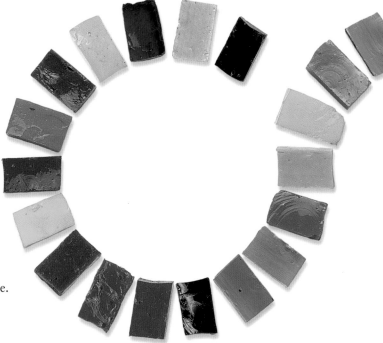

The Mosaic Palette

The mosaic palette is limited. You cannot mix infinite variations of color in the way that you can with paint. You will find in the current mosaic palette a shortage of yellows and reds, but many blues and greens. Pinks and purples are also thin on the ground, but there is other bounty to be found in copperized, gold, and silver tesserae.

Do not regard this as a limitation: relish the creative challenge it gives you. It will force you to find your creative edge, and that is when interesting things really start to happen.

In the Renaissance, when mosaics were made to copy paintings as closely as possible, many hundreds—even thousands—of different colored tesserae were available. The results

were stunning in their degree of skilful achievement, but lacked the true purpose and integrity of mosaic. Mosaic often thrives on a kind of stylization, in color as well as form: an almost iconic approach. This does not mean that mosaic cannot possess great subtlety and depth, but it does so within its own parameters.

Color Theory

A closer analysis of how color works is a useful exercise. Color can be regarded as possessing four basic properties: hue, tone, intensity, and temperature.

Hue is the term given to a color in its purest form in the color spectrum; blue and yellow, red and purple, for example.

Tone is the lightness or darkness of a color. Different hues can have the same tone: a red and a green, for example, can have the same degree of darkness, making them tonally matched. A dark-toned tessera will appear even darker if placed next to a light-toned tessera.

Intensity refers to the relative strength or weakness of a color, whether it is bright or muted. A bright tessera will appear all the richer placed next to a muted, heavy color.

The temperature of a color is its appearance of warmth or coolness. Generally, reds, oranges, and yellows are warm and blues, violets, and greens are cool. A cool color is "warmed-up" if it contains traces of a warm color. For instance, a bluish-green is cooler than a yellowish-green. Cool colors tend to recede, while warm colors advance.

Think about balancing or contrasting these qualities when you choose the colors for your mosaic.

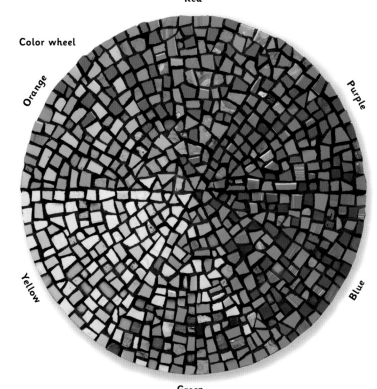

Color wheel

Red

Orange

Yellow

Green

Blue

Purple

Hue

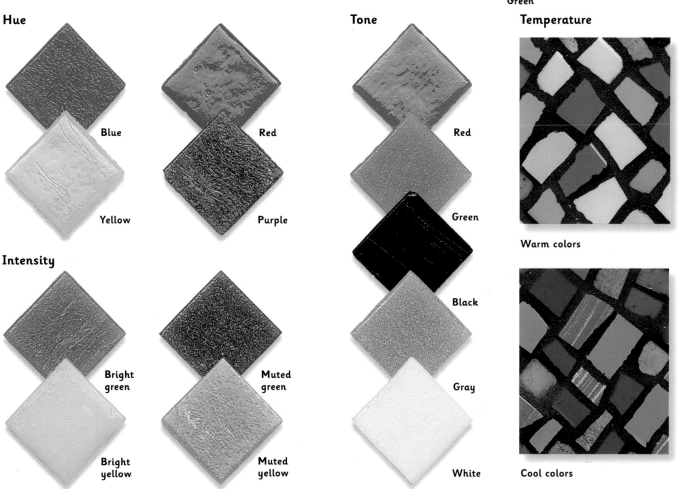

Blue

Yellow

Red

Purple

Intensity

Bright green

Bright yellow

Muted green

Muted yellow

Tone

Red

Green

Black

Gray

White

Temperature

Warm colors

Cool colors

Selecting Colors

When selecting colors for your mosaic it is a good idea to grab a handful of tesserae and lay them loosely over the area to be covered. Live with that choice for a short time, then try some other options until you are happy: it is so quick to do you can afford to be adventurous.

There are, however, a few specific points to consider that will help you develop your skills and confidence with color.

Areas of identically colored tesserae can be powerful and exciting. To achieve this effect, make sure you have all your tiles already "in stock." Different batches of a particular color are not always identical, so if you have to buy more tiles halfway through working you are unlikely to find a perfect match. On the other hand, a mix of closely related colors from different batches results in a subtle, interesting effect with great depth.

Try working in a pointillist way, mixing colors by mingling their composite hues. Mixing shades of red and blue, for instance, will create the effect of purple when you stand back and view the mosaic from a distance.

Use gold and silver with care: introducing any of these can produce a stunning effect, but too much looks terrible. The sheer cost will probably act as a deterrent anyway.

Move away from your work from time to time to get an overall assessment of its appearance.

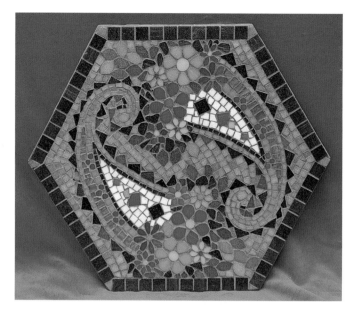

Above This mosaic, based on the ancient Paisley pattern, contrasts bright and muted colors.

Above Mixing small blue and red tiles over a large area can create the illusion of purple when viewed from a distance.

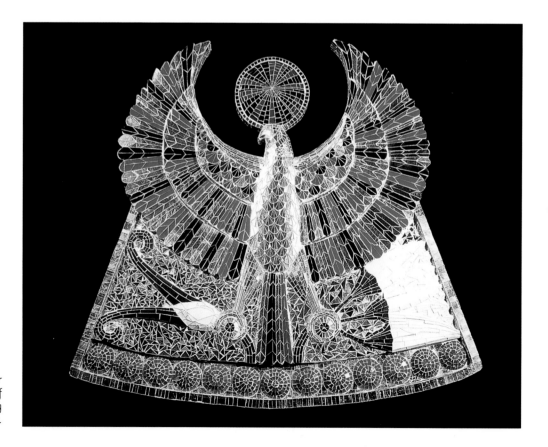

Right The gold and silver tesserae in this wall relief are balanced by strong reds and blacks.

WORKING WITH COLOR **21**

The Effects of Grouting

Grouting a mosaic has the most profound and extraordinary effect upon it. It is as if the mosaic has finally "become" itself; it takes on an air of inevitability and permanence.

Grout is something you need to think about early on in your mosaic planning. It is fundamental to the whole mood and impact of the finished work. Watching your completed mosaic emerge through the grout in its final incarnation more than makes up for the drudgery of seemingly endless wiping and cleaning. There is no going back on grouting; you have to get it right first time. For this reason, do not hesitate to work up some sample panels to experiment on if you have any uncertainty about your choice of grout color.

Gray grout provides an excellent neutral frame that shows off any color of tessera, except gray, of course. Gray often has the greatest unifying effect, treating both black and white equally. The brightest tesserae colors gain in brilliance and purity, softly glowing, like jewels.
Gray grout is a practical choice as well.
If your mosaic is going to be walked
on, whatever color grout you
start with is inevitably going
to end up gray.

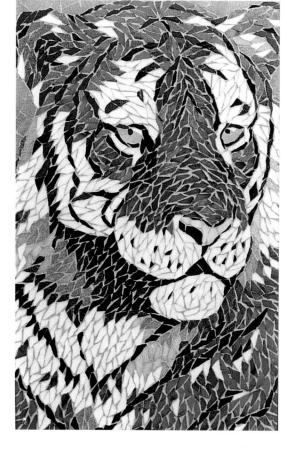

Right The yellow grout in this mosaic has the effect of "warming" the image up, while also unifying it. the grout echoes the color of the eyes.

White, gray, and dark grouting

White grout complements light tones so is good for showing off pale mosaics. Used on brighter, stronger, colors, it has a Mediterranean feel. White grout draws attention to the gaps rather than the tesserae themselves, so darker tesserae will appear isolated from each other, rather than unified.

Dark or black grout unifies dark-toned tesserae and isolates light ones. It increases the intensity of the tesserae colors so that they seem to glow.

Colored grouts should be used with care. The grout provides a frame around each tessera, however narrow your gaps are, and the way it sets the tesserae off has a major effect on the look of your mosaic. Think of a picture frame: its job is to show off the actual picture, not compete with it. Colored grouts tend to compete with the tesserae, but can work well in modern, abstract mosaics. Do, however, experiment and have fun with them.

Mosaic tools

DESIGNING YOUR OWN MOSAIC

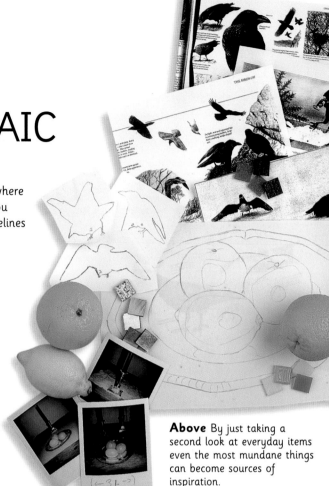

Translating an idea from the moment of inspiration to the point where it becomes a physical reality may seem like a daunting task if you haven't done much of this kind of thing before. Here are a few guidelines you can follow to eradicate any doubts.

Inspiration

Your inspiration for a design can come from anywhere: an image noticed and stored, magpie-like, in the memory banks of your mind; a collection of postcards; fragments of material; a motif on a piece of china; and, of course, any of the designs, motifs, or color combinations featured in this book. Look afresh at domestic objects that are close and familiar, or turn to the natural world. Perhaps a section of a machine looks interesting, or a piece of carpet—woven and printed fabrics are a great design source. You might even be inspired by a mood or an atmosphere. Your design can contain abstract forms or recognizable images and can have a contemporary or traditional feel to it.

Above By just taking a second look at everyday items even the most mundane things can become sources of inspiration.

Translating the Idea

Now all you have to do is analyze exactly what it is that has inspired you, and translate it onto paper. Drawing is an essential tool if you are translating your own design ideas. Draw vigorously and without fear. Remember that your design is not valuable in itself, merely in the information you are putting down on it. There is no imperative to get it right first time; feel free to have several attempts. Relax! You don't have to be the world's greatest draftsperson in order to design a wonderful mosaic.

Until you have gained some experience, keep your design simple. Starting off with too much detail and an over-complex design seems to be the biggest mistake that beginners make. Remember that a simple, well executed mosaic can be totally stunning.

At this point it is a good idea to start thinking about color and mark any ideas you have on your drawing.

Mosaic is completely different from painting or drawing and should be treated as such. In preliminary sketches, try to refine the subject of your mosaic to its bare essentials. The nature of the medium naturally suits a stylized, almost monumental approach. When in doubt, simplify. Avoid a gentle, naturalistic approach and try to express the intrinsic energy of your subject. Strong silhouettes are often important in getting the character of your subject across: if the outline can "tell the story" on its own, you will have no problem.

Left By piecing together separate elements in one sketch, you can create your own unique mosaic composition, as the author has done here. You can see the finished work in the Gallery on page 116.

Sourcing From This Book

You can choose to use the motifs and patterns illustrated in this book in a number of ways. On one level, you can browse through the pages in search of a source of inspiration that will help you design your own mosaic. However, if one mosaic in particular takes your fancy you can replicate it by photocopying the template to guide you more closely.

Enlarge the design to the desired size using a photocopier. Be aware of the scale: if you want to closely follow the pattern of individual pieces, make sure your chosen tesserae will cut comfortably to the sizes required. Transfer the design onto your surface using carbon paper (see Creating the Original Design, page 14). The two colorways that accompany each motif suggest different treatments that could be carried out. All the colors are based on easily available tesserae.

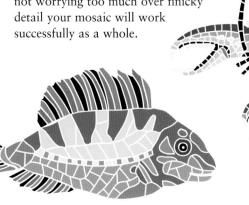

Humming-bird

One colorway uses the colors available in vitreous tesserae, the other in unglazed ceramic. However, this doesn't mean the mosaic will only work in these particular ranges. If you find materials that work for you, use them!

I suggest that you use these motifs as a guide to the colors, shapes, and directional flow, rather than as a pattern to be followed exactly. Spend some time analyzing exactly which elements in the mosaic are the most important, and focus on those. By concentrating on the overall scheme and not worrying too much over finicky detail your mosaic will work successfully as a whole.

Sun disk

Fish & lobster

How to use this book

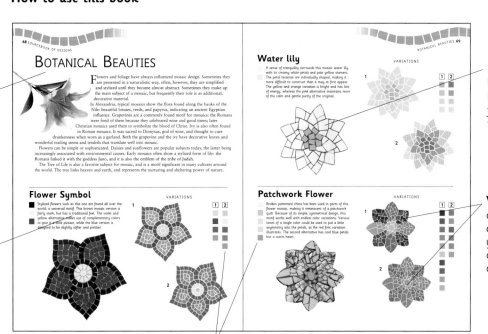

Introduction. Evocative and inspirational, this will inform you about the history of each section.

Motif text. A description of the methods and color theory behind the original motif and the variations.

Motif. Each motif has been created by top mosaicists from all over the world.

Variations. Two alternative colorways inspire you to try new and exciting combinations.

Color palette. The number and hue of the mosaic colors needed for each motif, both original and variations, are clearly provided for those who wish to replicate these templates exactly.

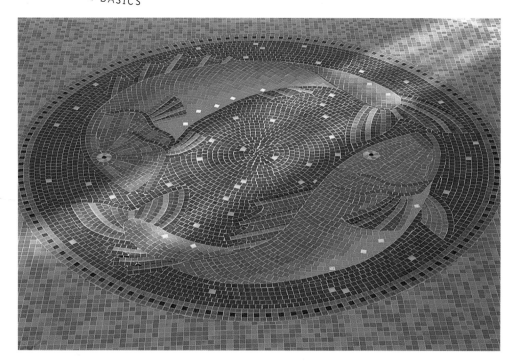

Above The blues in this swimming pool mosaic are enhanced by being under water. The shapes are large and, therefore, easy to read from numerous angles.

Practical Considerations

If your mosaic is to be a self-contained "picture," there is no need to take account of any environmental factors. If, however, it is to be installed in a specific site, then it should be designed with reference to the architecture and color scheme that it is destined to become a part of. For example, if your mosaic is going to be sited in a small room, do not make it too large or busy. If your mosaic surface is curved, like the outside of a pot, remember that you will only see a part of the design at any one time. Beware of deeply fashionable trends, and avoid them: they have a habit of quickly becoming deeply unfashionable.

Composition

If you are unsure how to structure your mosaic visually, you could do worse than to take a leaf out of the Romans' book and use medallions or motifs on a simple background, surrounded by a basic or intricate border.

Your central subject, or motif, should sit easily in its surrounding space. A common mistake is to cram a subject in so that the outermost edges of it are scraping a rather skimpy border. So think about space and try not to let the mosaic become cramped.

Borders are great; they seem to complete a composition and help to balance out the visual structure. When choosing a design and colors for a border, remember why it is there: to support and show off the main attraction in the central part of the design. Beware of making it so bright and jazzy that it competes with what is happening in the middle (unless you are making a mirror frame, in which case you can just go for it). In particular, resist the "traffic light" urge: repetition of a sequence of two or three bright colors: it rarely works. On the other hand, the border ought not to be too wishy-washy or insubstantial either. Tonally, it should carry some weight, and form an integral part of the balance of your composition.

Whereas the border should balance the motif tonally, the background should definitely not. This is where you need contrast: ensure that your background color scheme is tonally either darker or lighter than the subject. Do not be afraid of plain areas: the Roman mosaicists called it *horror vacui*, fear of empty space. If you don't want a background that looks too flat you can add texture and interest by subtle variation in the colors you select.

Below The blue background contrasts well with and enhances the bright colors of the chilis. The andamento flows horizontally across the background, making the vertical chilis stand out more.

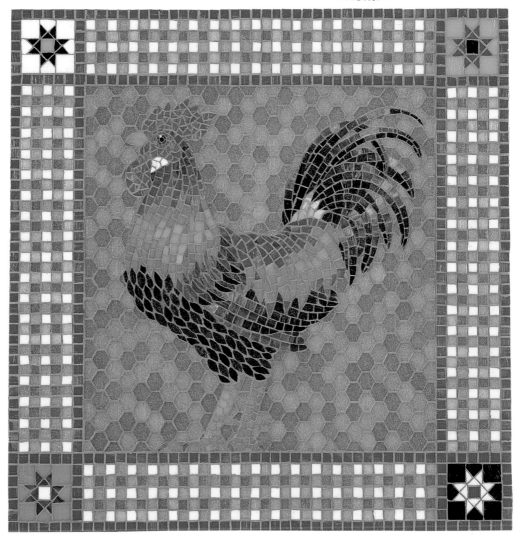

Right The border in this mosaic is well balanced with the central motif—the border is interesting in its own right, but does not detract from the main composition.

Scale

It is a good idea to design on the same scale as your final mosaic. This is because it is easier to visualize the capabilities of the particular sizes of tesserae that you want to use. Small tesserae will be more fiddly to glue down, but have greater flexibility when winding around complex shapes or going into awkward corners. Larger tesserae might tempt you because they cover a greater area, but they may well need individual shaping and, in the end, slow you down. So try to design with your tesserae in mind.

If you prefer to make a small sketch it will need enlarging, and there are two sensible ways of doing this. Firstly, the good old-fashioned grid technique: draw a grid of squares over your design, and another, larger one with the same number of squares on a sheet of paper the same size as your mosaic-to-be. Number the two grids identically, then carefully copy the design in the small grid onto the larger one, square by square. Alternatively, take your design along to the nearest photocopier and photocopy it to size. This way you are sure of keeping the spontaneity and flair with which you originally drew the design.

Below To enlarge a mosaic design to its ultimate scale use the grid technique.

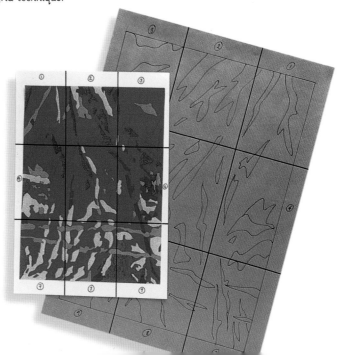

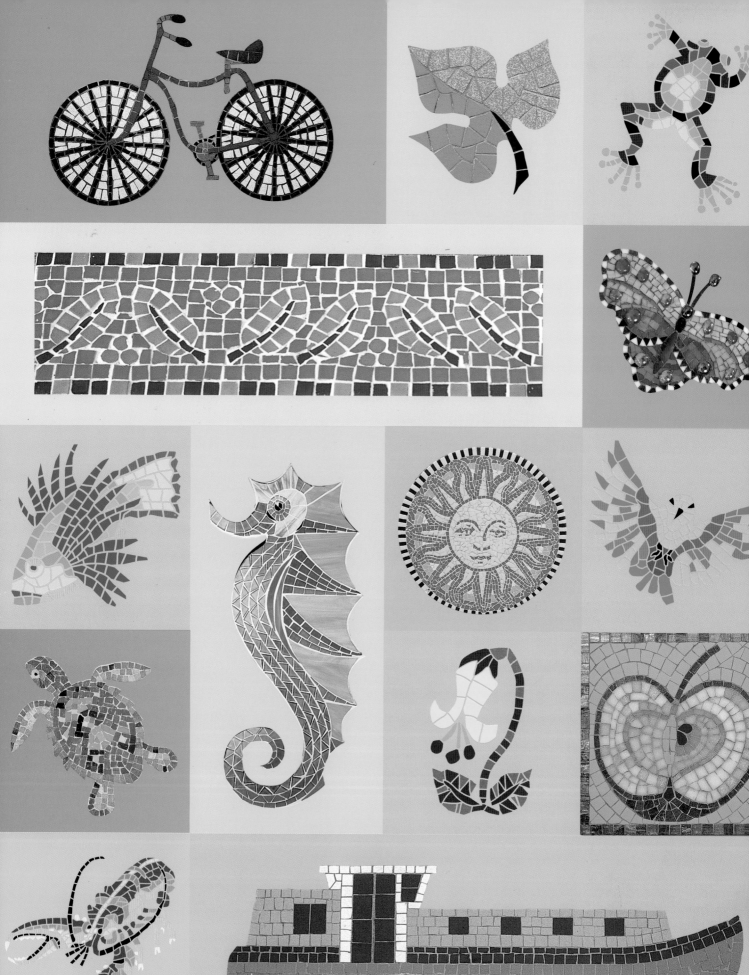

SOURCEBOOK
OF
DESIGNS

Mosaicists from all over the world have contributed to this section, hence the motifs vary greatly in style, from bold, simple designs to complex, delicate work. Each original mosaic is accompanied by two alternative colorways, illustrating how trying out different combinations of colors can open up endless visual possibilities.

THE ANIMAL KINGDOM

From prehistoric times, humans have been inspired to portray animals in their art. Some animals have been worshipped as gods or even ancestors, and they are often used symbolically: we are all familiar with the lamb as a symbol of Christ, or the lion implying strength and valor. The reasons for choosing to show an animal in any art form can be spiritual, symbolic, or simply aesthetic.

In mosaic art, animals are widely employed as subjects. A particularly charming example, dating from the Romans, is the little mouse picking its way among the household debris shown in versions of the "unswept floor" theme, a design that makes decorative and witty use of bits and pieces that ended up on the floor. Also on a domestic front, the famous *Cave Canem*—beware of the dog—depicts a fierce dog set in the doorway of a house in Pompeii.

European mosaics featured animals that were hunted locally, as well as more exotic animals from distant lands, such as elephants, zebras, and giraffes. These were hunted and trapped for circuses and contained an almost mythical status. Sometimes, the depiction of these animals ended up slightly distorted, either because the mosaicist was unsure of his subject matter, or because they were unnaturally made to fit into a particular space in the overall piece.

Animals are just as popular a theme in today's world. They make beautiful, funny, charming, powerful, and moving subjects.

Pig

This quirky little pig has an air of spontaneity about it, and the color is bright and happy. The tesserae used are all different shapes and sizes, which adds to the humor in this piece. The variations suggest a gray pig with pink spots, that is not at all realistic yet suits the overall mosaic, and a black and gray pig that is fairly realistic.

VARIATIONS

1	2

1

2

Ginger Cat

Tail up, this ginger cat stands with its green eye calmly gazing ahead. The use of slightly varying brown tones on the body give a gently rounded effect. The shadowy undercarriage, made from darker tesserae, emphasizes light falling from above. Spotty and stripy variations are also possible, using natural shades or completely unnatural colors, just for fun.

VARIATIONS

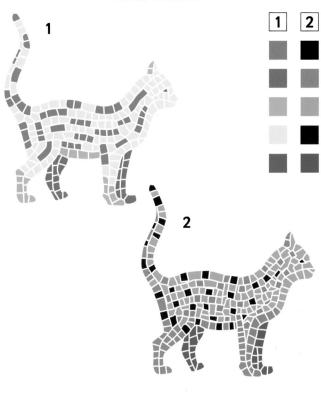

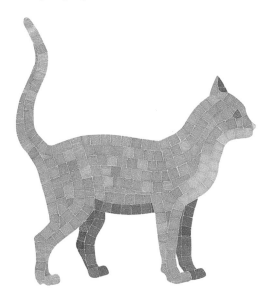

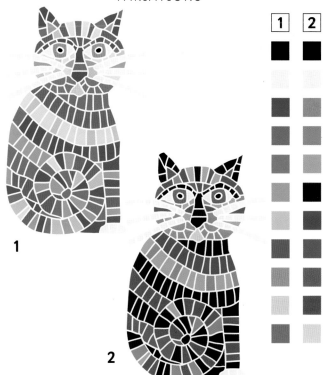

Sitting Cat

Curving stripes and a spiral tail give this cat a very distinct character. Reinforced by the use of a dark grout, it is bold in design and execution. The bronze glitter in the huge eyes adds an unexpected depth. One of the variations uses a blue and green palette that is not out of place as the design is so stylized; the other is a darker, more muted version of the original.

VARIATIONS

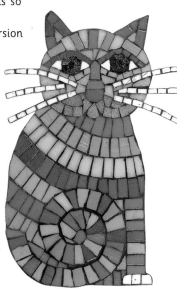

Terrier

This pebble mosaic depicting a real terrier called Dorothy illustrates her marvelously sturdy character. If you cannot find pebbles in the different tones suggested for the variations, you could shape tesserae instead to gain a similar effect, although it may not be a quick option. Note in each case how the judicious use of a few lines of black pebbles helps to define the dog's form.

VARIATIONS

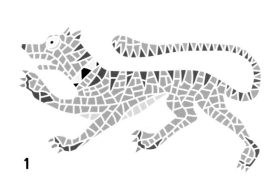

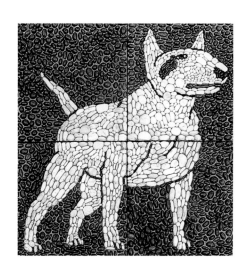

Classic Dog

This side view of a dog is lively and expressive. It looks a little like a heraldic beast from a coat of arms, but a more down to earth and humorous version. The lines of tesserae flow mainly horizontally, which contributes to the sense of forward motion; this dog is in a hurry. The colors used are pleasing and solid. The two variations move in opposite directions with regard to color, one using bright and undog-like shades and the other employing a more naturalistic look.

VARIATIONS

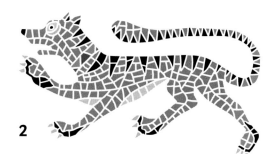

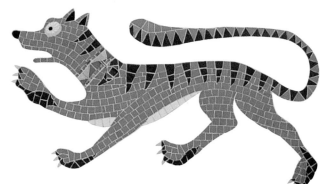

Mouse

This "wee, sleekit, cow'rin', tim'rous beastie" (To a Field Mouse, Robert Burns) of a mouse is admirably portrayed in discreet, mouse-like grays. The use of narrow lines of tesserae help to streamline it, and the sharp black tail adds urgency and tension. The first alternative colorway is suggestive of a pink sugar mouse, while the second variation is carried out in warmer, countrified tones.

VARIATIONS

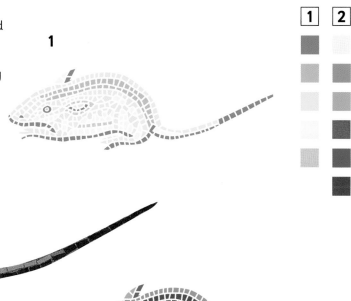

Hare

This gray mosaic hare is outlined in black: a useful defining mechanism that looks a little like running stitch. You can give the hare a more naturalistic treatment by working in more colors, especially around the ears, nose, and undercarriage. Either use shades of brown, or reproduce an artistic impression of a blue hare, whose fur takes on a pale blue-gray appearance in winter, which helps with camouflage in the snow.

VARIATIONS

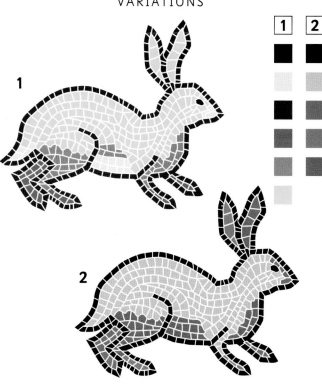

Leaping Hare

With its flying ears and legs mid-leap, this hare motif has a traditional look to it, and is very expressive of movement. Changing tones are used to mold its shape, but not gradually and smoothly. The progression from dark (black) to very light (white) is made using only four tones in between, which adds to the jerky, energetic effect. The two variations also make this journey from dark to light, one in blues and greens, and the other using a more varied range of hues along the way.

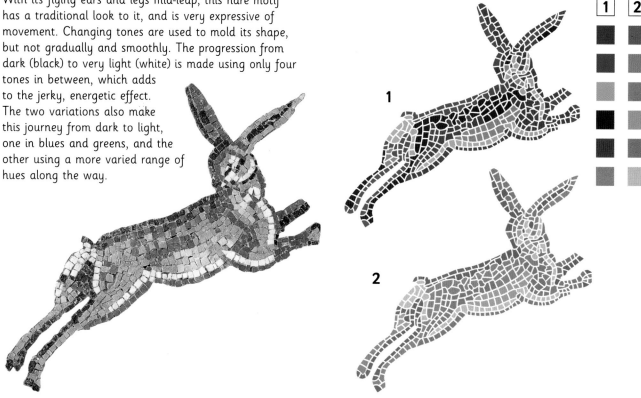

Seated Hare

Much of the success of this hare mosaic is due to its dynamic outline. The molding is beautifully thought out, the lighter areas tending to avoid the outline leaving it strong and dark, all except for the tender, vulnerable, soft underbelly. True artistry. The original uses fairly natural shades, so the two suggested variations offer more colorful alternatives, while remaining true to the tonal composition.

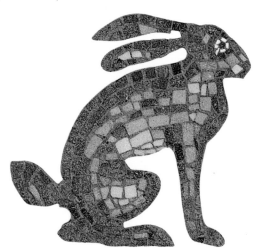

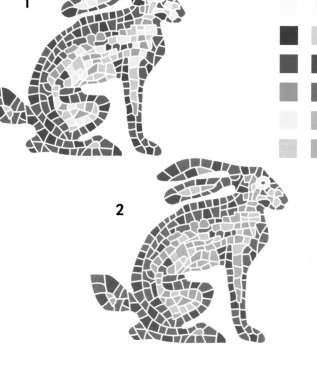

Hedgehog

This gorgeous hedgehog has a striking, spiny coat of dark, light, and mid-tones. The spines flow back from the head in a linear fashion, giving it a wild, unkempt appearance. The alternatives keep to a simple palette, but introduce more color. They both retain the three-tone pattern on the back.

VARIATIONS

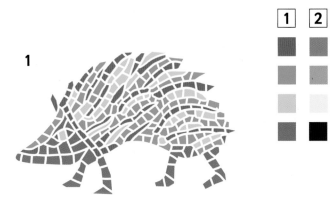

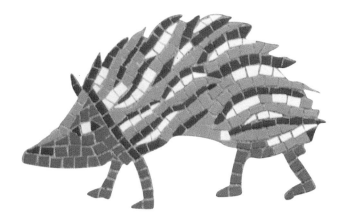

Bat

This gentle, fluttering bat has a prettier face than the real thing, but otherwise it completely captures the delicacy of these tiny creatures. Many tones have been used to construct its form, the lighter shades molding the body and limbs and bringing them forward, while the darker wings emphasize the silhouette. The direction of the tesserae also helps to interpret the form, stretching across the wings between the fore and hind limbs and curving around the body. The variations create a dusky blue bat and a shadowy purple one.

VARIATIONS

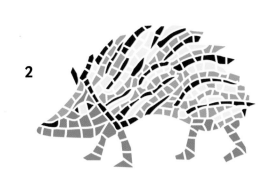

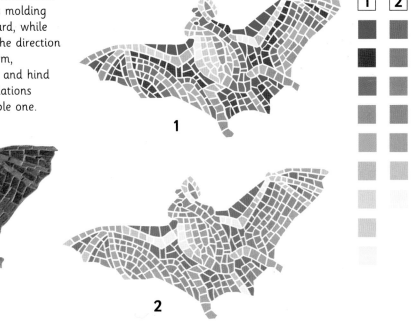

Goat

A mosaic goat is depicted with strength and vitality as befits a creature associated with agility and abundant energy. The hide of the goat is broken up into areas of bold color to imitate its shaggy coat and muscular form. These areas are full of curves and movement. The horns have had the same confident treatment applied to decorative effect. This motif does not need to be treated in a naturalistic way, as is illustrated in the more playful approach used in the alternative colorways.

VARIATIONS

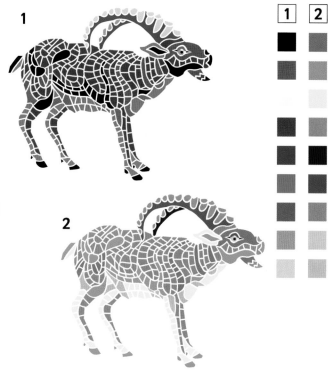

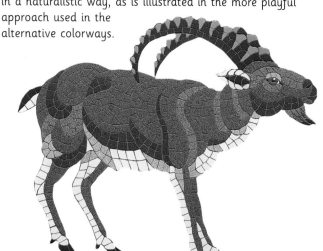

Ram

A little like a Roualt painting, this ram mosaic makes great use of its black outline to give it a fierce strength. Unless one is embarking on some very subtle foreshortening, areas such as the ram's head need this kind of definite treatment to tell the onlooker what is happening; in this case, that the head and horn are in front of, and more important than, the shoulder. The two variations maintain the tonal formula, but use more impressionistic hues.

VARIATIONS

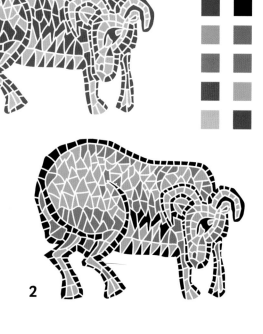

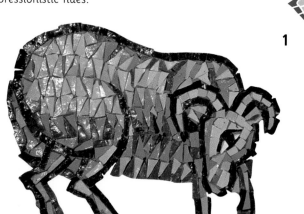

Bull

The importance of outline when defining a mosaic motif is illustrated beautifully in this bull design. The strong black contour creates a powerful and dynamic image. The andamento inside reinforces the outline, rather than distracting from it. The suggested variations, one in blazing reds and oranges and the other in cool colors, also respect that descriptive outline.

VARIATIONS

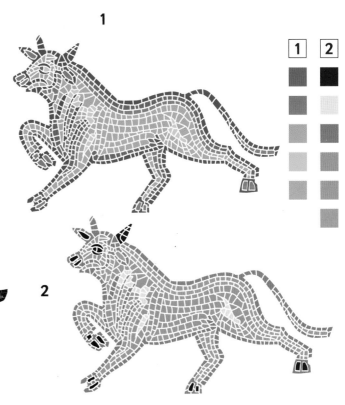

Cow

Influenced by folk art, this cow mosaic is simple, weighty, and very pleasing. A good example of how successfully a sideways profile of a subject can be translated into mosaic. Although the tesserae that edge each area of color describe the outline carefully, the tesserae within are more informally placed. This combination of precision and looseness works well. An alternative breed of cow could use reddish-brown and beige shades, or go completely wild with crazy colors.

VARIATIONS

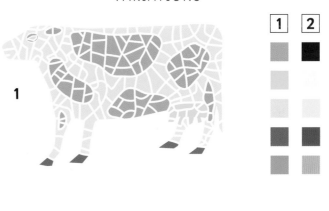

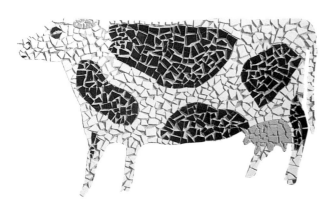

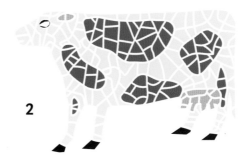

Stag

In mid-leap, this stag has the air of a mythological beast. The mosaic is quite stylized, using only a few simple colors, and the andamento produces graceful, sweeping lines of tesserae. The first suggested variation creates a more molded effect by grading the tones through the body. The second suggestion retains the simple, stylized formula but uses a darker palette.

VARIATIONS

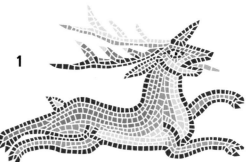

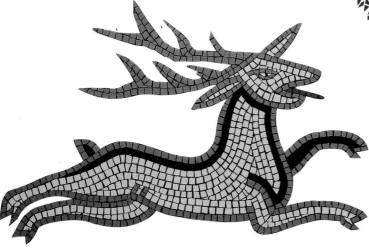

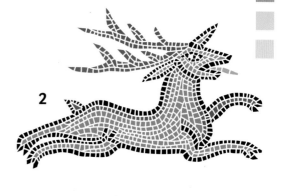

Racehorse

Here is a classic example of opus sectile: each tessera has been carefully cut into a shape unique to that part of the mosaic. Time consuming, but a technique that can be used to excellent effect, as illustrated here. The colors have been skillfully used to mold the form of the figures, and the result is an almost super-reality. The two variations do not stray far from the original concept, but provide a light brown and a cream horse for variety.

VARIATIONS

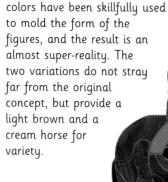

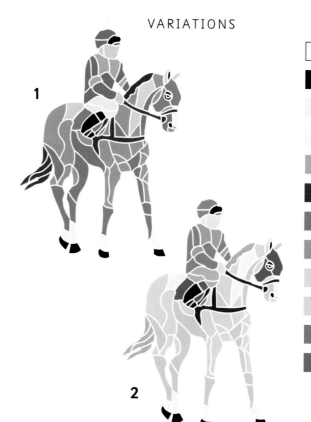

Elephant

Elephants are associated with wisdom, patience, and longevity; all qualities the mosaicist may like to meditate on when at work. This charming mosaic is not complicated, but flows in a pleasing and logical manner by following the form of the elephant in a most natural way. At the furthest extreme from the gentle grays of the original is a color variation inspired by the vivid hues of Indian embroidery, and a more subdued one in gentle pinks.

VARIATIONS

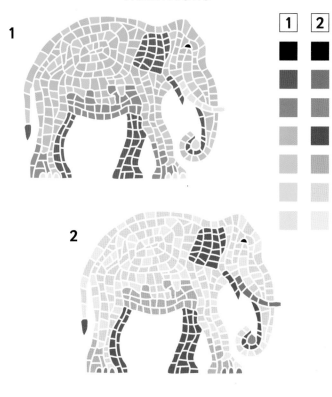

1

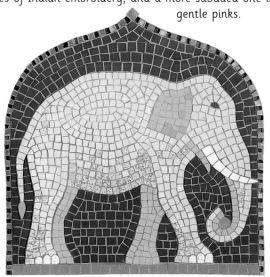

2

Rhinoceros

This rhinoceros mosaic is full of lovely, wavy lines that describe his form and skin tones. The gentle and varied shades of gray work beautifully together. In the variations, mixes of muted colors are used so that the andamento stands out and takes precedence.

VARIATIONS

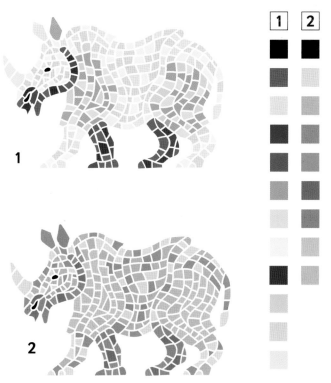

1

2

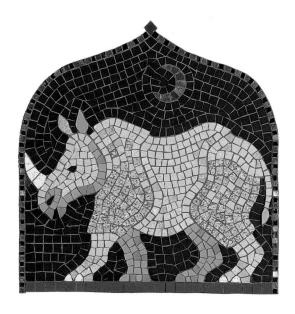

Snail

Graded purples make this snail's shell light up, and are well contrasted with the accompanying muted gray-green. The principle of using graded colors for the shell and maintaining a pale lower body color should be kept, whatever color combinations you use. The markings on a snail's back can be interpreted in any way you choose: you could introduce a completely new color to this area alone, for a bit of fun.

VARIATIONS

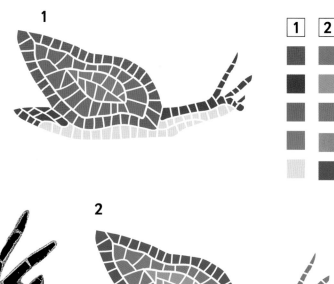

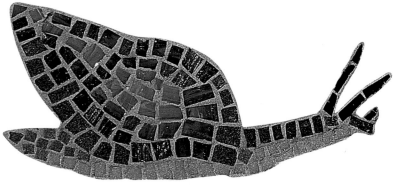

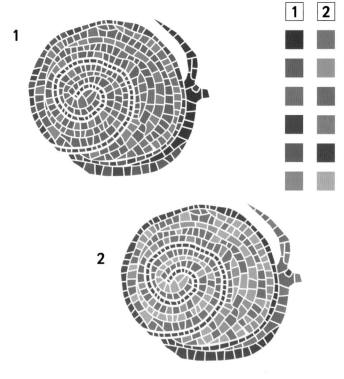

Elaborate Snail

The lovely, glittery-green glint of the copperized tesserae used on this snail's shell is well defined by the dark outline that holds the motif together, making it unified and compact. The lines of tesserae roll out from the center in a spiral formation. In both of the suggested colorways the principle remains the same, using dark tones for the outline and a mix of lighter colors for the shell.

VARIATIONS

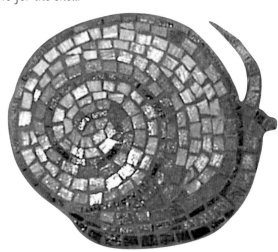

Multicolored Snail

Snails provide the perfect opportunity to employ a popular mosaic pattern—the spiral. Starting from the center with a light and a dark line, and winding outward, extra lines are introduced and removed as the coils of the shell grow wider. The shell colors are all warm shades, although they vary tonally from deep brown-black to pale yellow. The snail's body has less contrast, minging pale shades of pink. Both of the variations mix several colors for the shell and the body, and in each case the shell is brighter than the body.

VARIATIONS

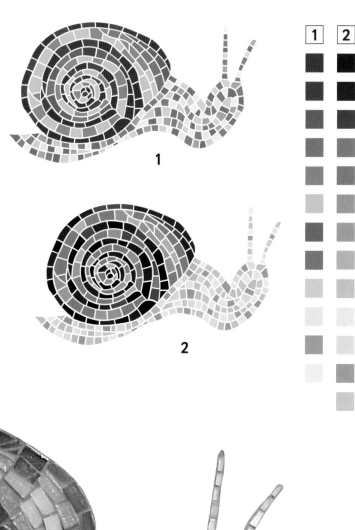

1

2

Long tesserae are used in the shell to emphasize the linear effect.

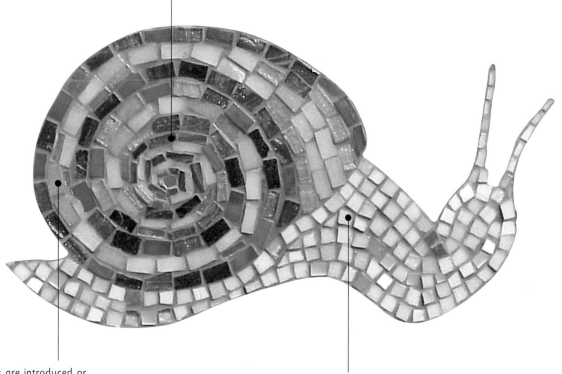

Extra lines are introduced or dropped at will in the shell to create movement.

Delicate pinks contrast with the warm colors of the shell in the smooth, curving andamento of the body.

Poised Frog

This frog, poised as if ready to jump, is full of life and movement. The coloring of the mosaic is rich and varied, the blue-green dots adding a frisson among warm, coppery tones. The first variation plays the same trick, using sharp ultramarine dots among muted greens. The second variation puts yellow ocher dots against deep browns for a more subtle effect, while the blue provides an exciting change of hue.

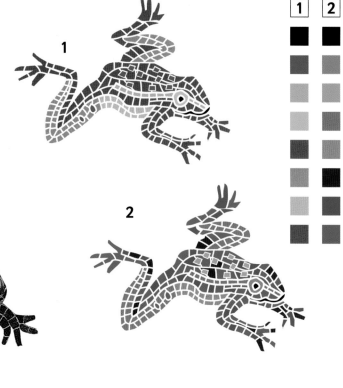

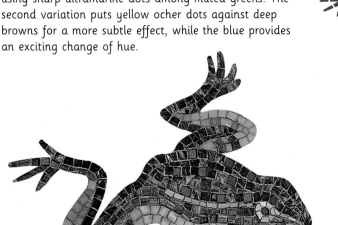

Jumping Frog

Simple but full of movement, this frog mosaic juxtaposes light and dark toned tesserae. The toes, highlighted in a color used only on the eyes, add a fun decorative touch. The lines of tesserae follow the body shape, emphasizing its roundness. One possible variation contrasts dark purple and light greens, reminiscent of poisonous frogs that live in the jungle. Alternatively, use coloring that is close in tone and hue, such as the warm reds and browns of the second variation, but have some fun with blue toes.

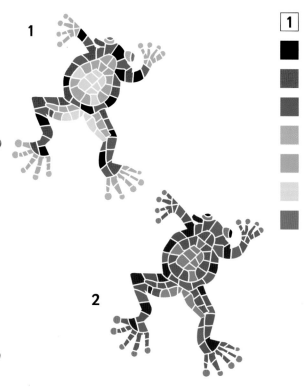

Sitting Frog

The quiet greens in this frog mosaic give it a natural, discreet charm, which the hints of mauve do not detract from; rather, they lift the image a little. The delicate outline and the andamento accurately describing the form of the back and hind legs combine to make this a very successful depiction. A bright, hot alternative, uses vibrant colors, but keeps the mauve touches. A cooler suggestion uses blues instead of greens.

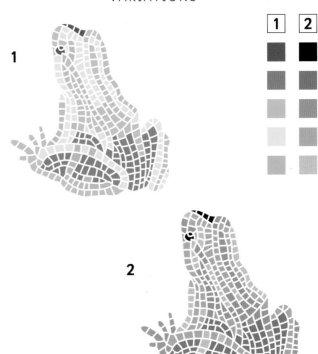

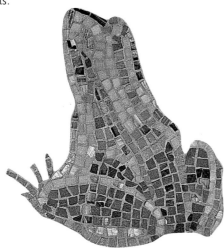

Great Crested Newt

As if waiting for something to happen, this newt is poised, ready for action. The mainly dark tones of tesserae used give him a look of independence: he stands out from the crowd. The variations bring in a few more colors, without going wild. Pond-like greens and browns look wonderful as almost natural newt colors, and it is worth experimenting within this range. An outside color, such as purple, can be brought in to add some vibrancy where necessary.

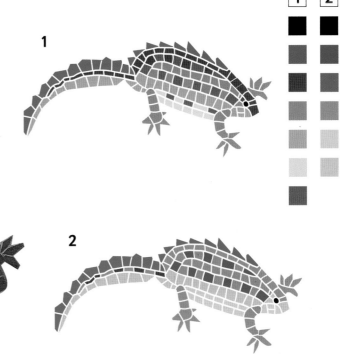

Lizard

Lizards are a favorite theme of mosaicists everywhere, and it is easy to see why: their sinuous curves make them a wonderfully decorative shape. This exotic lizard has been made using different kinds of gold smalti, with a couple of pieces reversed to make those jewel-like eyes. The two variations both exploit the colorful and decorative possibilities of this charming creature.

VARIATIONS

1

2

Running Lizard

A wonderful wiggly shape, this lizard mosaic is simple yet successful. The main structure is held together visually by the use of strong greens and yellow, with white providing a dashing contrast. One of the great things about lizards is that they can be almost any color. These variations feature warm golden browns with sharp blue patterning, and blue and black highlighted with red: all strong colors that each stand their ground.

VARIATIONS

1

2

Curly Lizard

A timeless motif, this mosaic lizard has a primeval feel to it. The main shape of the body is held together by the lovely textured green, with interesting variations in color and tone in the tail, as if it has dropped off and grown back several times. The dots along its back, which turn into a line down the middle of the tail, are an extra ornamental detail and add interest. The first variation juxtaposes yellow and orange with opposing mauves, and the second combines blues sharpened up with some deep red detail.

VARIATIONS

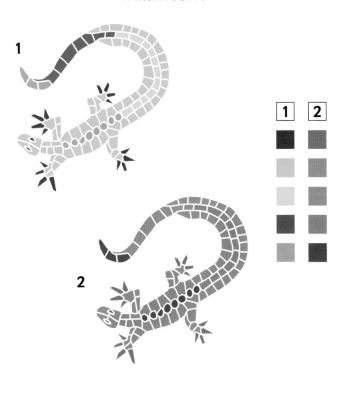

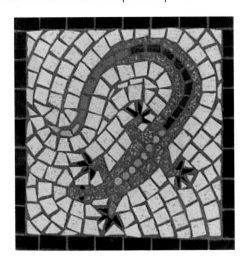

Aztec Lizard

The zigzag lines and diamond patterns on the lizard's back give this mosaic a Mexican feel. It utilizes plenty of bright colors, similar in tone, which are fairly evenly dispersed about the motif. The black outline tesserae hold it all together. Similarly bright alternatives could be tried, or experiment with a more earthy approach using browns and reds. Remember to always use a dark tone to outline the overall shape.

VARIATIONS

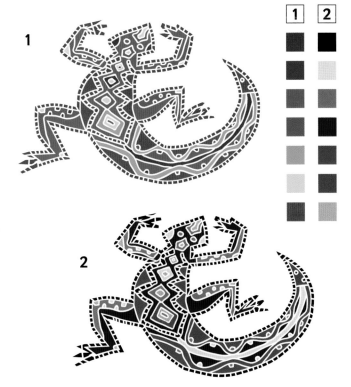

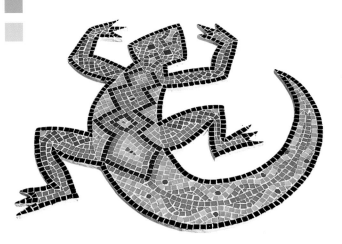

Coiled Snake

This beautiful snake is coiled very realistically. The strong outline is necessary to define the coils, and is also decorative. Note how each tessera on the snake's body has been roughly rounded to imitate the snakeskin pattern—the motif is composed simply of dots and curving lines—and the bars across the snake's body are worked in a dark, light, and mid-tone. The variations show one poisonously bright version, and one in warmer, mellower colors.

VARIATIONS

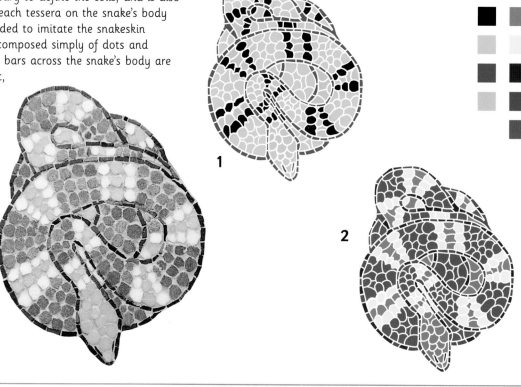

Wriggling Snake

This twirly snake mosaic is interesting because the actual body is composed of dark grout, with the beautiful tesserae marking the pattern set in amongst it. The surrounding line of tesserae is essential for defining and containing the snake's body. The color of the grout and the surrounding tesserae contrast tonally. Like the original, the variations mix plenty of carefully chosen colors for the pattern on the snake.

VARIATIONS

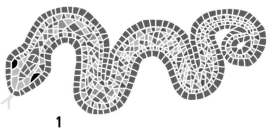

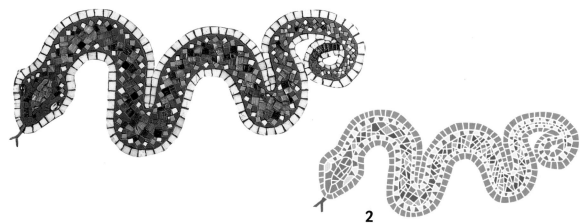

Chameleon

If ever a motif gives you license to choose whatever colors take your fancy, a chameleon must be it. The graded tones, particularly in the eye area, give this creature an enigmatic air. The alternative colorways show the chameleon in contrasting moods: all fired up in red, orange, and pink, and a woody, brown study.

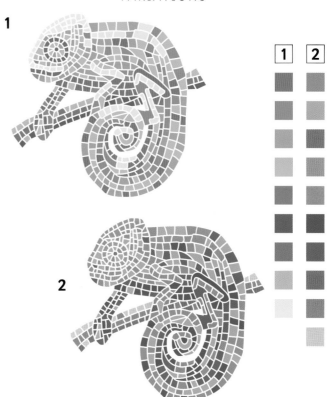

1

2

1 2

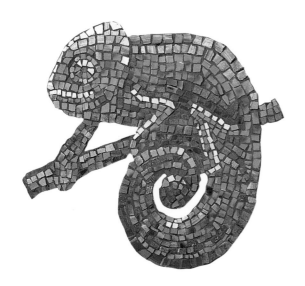

Dragon

A wonderfully fiery dragon mosaic features lines of tesserae flowing in flame-like swirls, with vicious gold teeth and claws glinting as they catch the light. Although the colors used vary in tone, they are similar in hue. The suggested variations—one using murky greens and the other in a range of blues—are designed to work in exactly the same way.

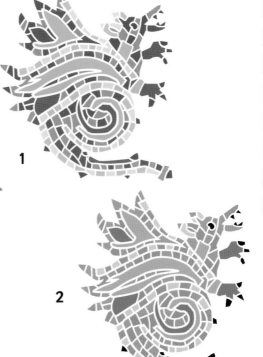

1

2

1 2

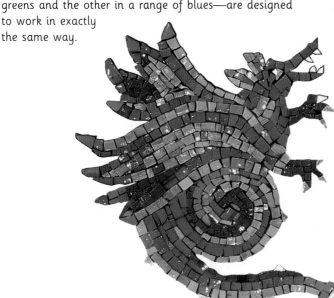

THE BIRDS & THE BEES

Birds come in many shapes and sizes, and have proved a powerful inspiration to mosaicists through the ages with their aerodynamic forms and glorious plumage. They have a symbolic value, too: doves for peace, peacocks for immortality and watchfulness, and ravens as messengers.

Stunning necklaces and earrings from ancient Egypt feature vultures and falcons, their feathers encrusted with precious stones such as lapis lazuli, carnelian, and obsidian, as well as colored glass. Scarabs, too, were given the same treatment. Apparently, as symbols of resurrection, they were the most popular good luck charm in ancient Egypt.

Birds that were hunted locally were often shown in Roman mosaics: cranes, ducks, geese, and other waterfowl. A particularly famous and much copied mosaic is *Pliny's Doves*: doves perched on the rim of a bowl at Hadrian's Villa in Tivoli, and actually mentioned by Pliny the Elder in the first century A.D.

Insects make fascinating motifs for mosaic, maybe because capturing the contrast between delicate wings and firmly defined legs and bodies is a rewarding challenge. Perhaps it is because their outlines are so expressive of the whole creature. Another reason might be that translating them into mosaic exploits their decorative potential to the maximum, while at the same time reducing the creepy-crawly aspect. Bees were particularly popular in Byzantine mosaics, the hive representing the Christian Church. Bees also stand for hard work and industry. Butterflies and dragonflies are also often to be found in mosaics—there are some beautiful little eighteenth-century micromosaics featuring butterflies—their wings providing a great opportunity to revel in lots of color.

Kestrel

The wing feathers on this soaring mosaic bird of prey have been carefully crafted to indicate the actual structure of a bird's wing, while the dark colors give the main design a feeling of tenacity. The various treatments of this motif show that you can aim for a look closely based on natural coloring, or try something exotically different, such as the blue of the first colorway.

VARIATIONS

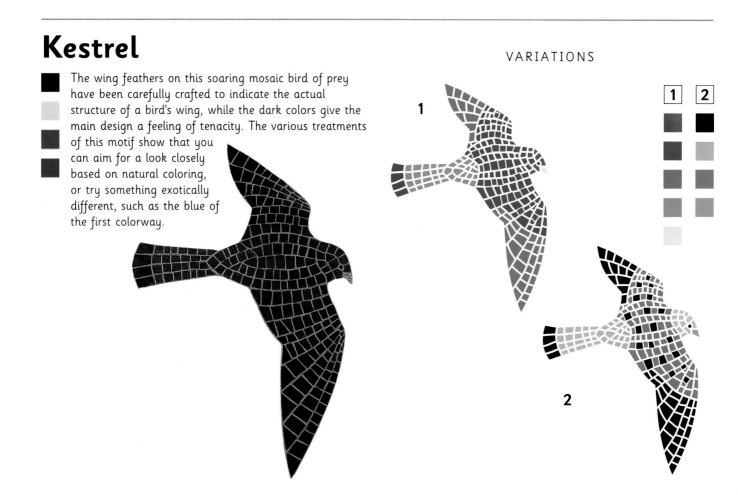

Dove

The andamento is an important factor in expressing the form of this flying dove; particularly the outside line of the top wing as it runs down over the head. The original uses natural dove colors for a reasonably realistic effect, but you can add more color to the bird for a stylized look, such as the serene blues and greens or soft pinks used in the variations.

VARIATIONS

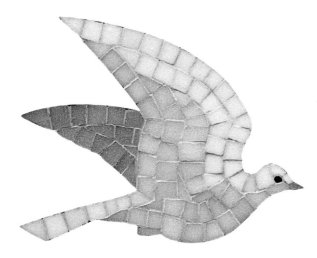

Moorhen

The moorhen has a simple form but makes a charming design for a mosaic, with its characteristic flashes of white on black, and yellow legs. A natural effect can be produced using realistic colors. Alternatively, use a little artistic license and vary the color combinations, but keep the formula the same: a dark tone for the body with touches of color here and there, and light flashes on the wing and tail.

VARIATIONS

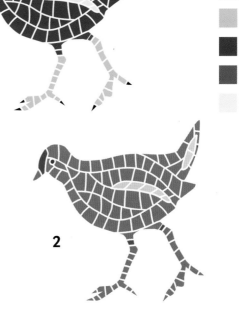

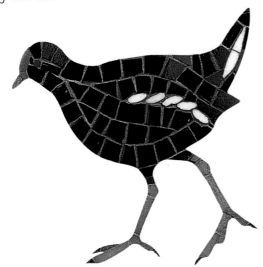

Bird in Flight

A mosaic flying bird displays a wonderful sweep of wings, its feathers braced against the air current. Every feather has been individually constructed; the pointed ends create a dramatic jagged outline. Touches of bronze metallic smalti amid the ghostly whites and grays add to the magic. The first variation combines cold greens with closely related "warm" blues, with a strong, "warm" green for the flashes on the wings.

The second variation contrasts yellows with dark blue flashes.

VARIATIONS

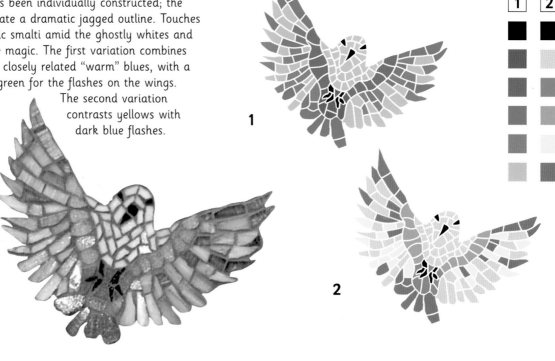

1

2

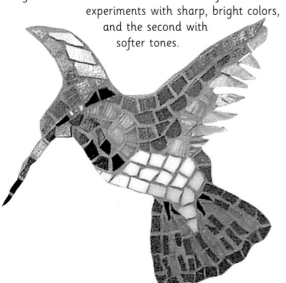

Hummingbird

A range of tones and an interesting balance of colors— mauve interfacing with warm, strong green and set against a light, cool green—combine wonderfully, to bring this hummingbird mosaic to life. The copperized tesserae add to its brilliance, The wing feather tips have been constructed individually, and this spiky effect brings more variation to the outline. The first variation experiments with sharp, bright colors, and the second with softer tones.

VARIATIONS

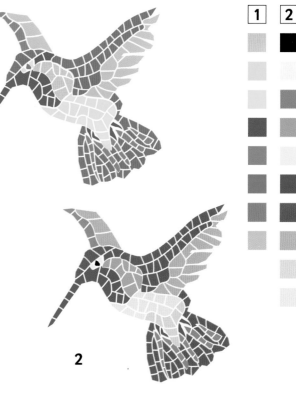

1

2

Cockerel

A realistic cockerel mosaic is created by successfully combining dark and light tones and warm and cool colors, to make an interesting and lively motif. The use of smalti gives it a wonderfully textured, chunky look; you can just see the light reflecting off it. Note how the tail feathers overlap and fall in front of the wing, creating a three-dimensional effect. Each area of what looks like a single color actually features slight variations in shade. The first alternative uses a similar technique but in warm shades of red and orange to create the proverbial Little Red Rooster, while the second variation uses a variety of colors for an abstract effect.

VARIATIONS

1

2

Cold, dark colors are combined to create the tail feathers. The green and blue tesserae effectively "catch the light."

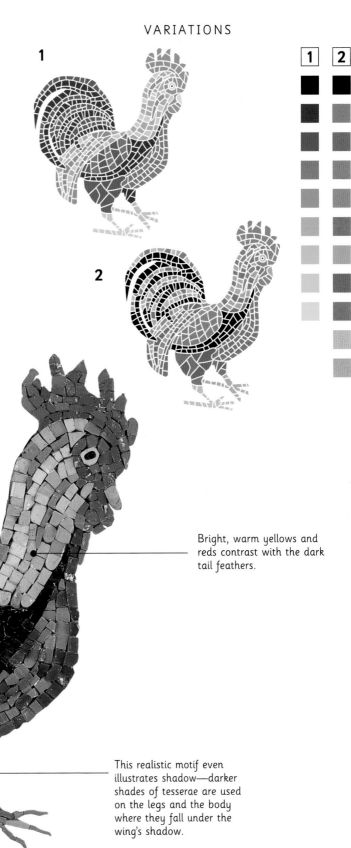

Bright, warm yellows and reds contrast with the dark tail feathers.

This realistic motif even illustrates shadow—darker shades of tesserae are used on the legs and the body where they fall under the wing's shadow.

Parrot

The bold, glinting eye and gawking mouth of this chunky and bright parrot produce a happy expression. Smaller tesserae are applied around awkward solid shapes, such as the tight curves of the eye, to create a neater finish. The white grout intensifies the dazzling effect. One variation creates a bright blue parrot, and the other illustrates a parrot in shades of green, jungle colors.

VARIATIONS

1

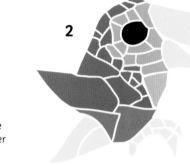

2

1	2

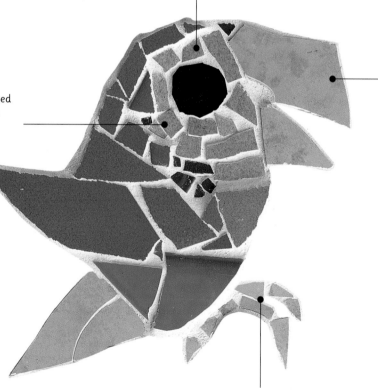

The round tesserae for the eye provide a contrast to the angularity of the other, larger tesserae.

The light mauve tesserae used on the cheek contrasts with and helps to emphasize the dark eye.

The wide open mouth conveys the impression that the parrot might be uttering some well-learned lines, singing, or even laughing.

The curved claws indicate that the bird is sitting on a perch or a branch.

Hen

Many of the tesserae have been individually cut into lozenge shapes to form this cheerful hen mosaic, and the grout plays a prominent part in showing them up. The eye looks as though it has been painted on; another way of achieving this effect is to drill a shallow indentation into the tessera after it has been grouted and has set, then rub a little grout of your chosen color into the indentation. A greater tonal mix has been used in the first variation, although the color scheme is similar. The second alternative uses more extreme tones, but very little variation in color.

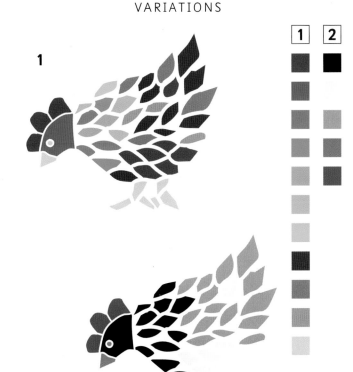

Peacock

A lovely combination of blues is used to form this chunky, stylized peacock mosaic, and the yellow-gold tesserae in the tail provide a stunning contrast. The details (beak, legs, and head feathers) are not delicately portrayed, but executed in strong, dark tesserae, which help to unify the whole motif. The first variation puts the emphasis on green, using a wide range of shades, whereas the second alternative sticks to a less complicated palette, with equally effective results.

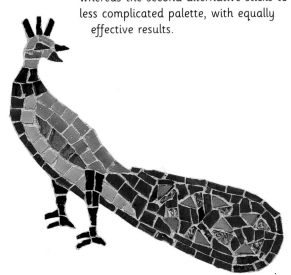

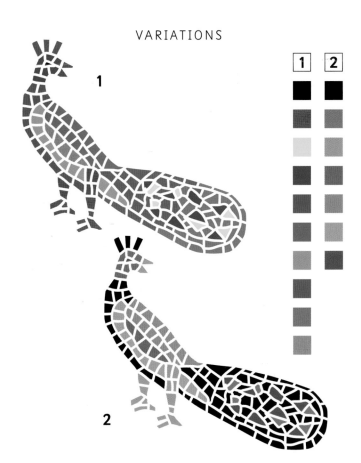

Butterfly

This little butterfly has been rescued from appearing too solid and heavy by gradating pale to dark blue outward from the body and rimming the wings with a much lighter color. The same gradating treatment can be used with other color variations, such as purple and mauve, or using shades of yellow and warm yellow-brown.

VARIATIONS

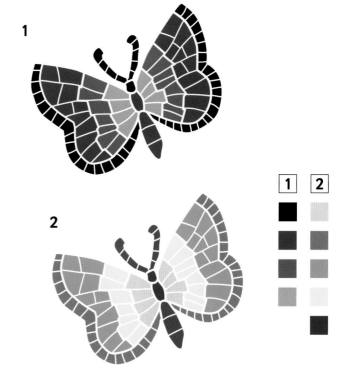

1

2

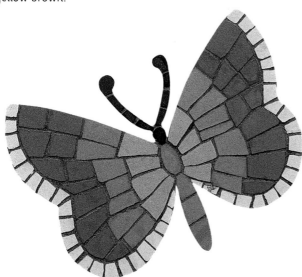

Chalk Hill Blue

This butterfly replicates a male Chalk Hill Blue. The wings feature several graded shades of soft blue, which create a sense of delicacy, but the black dots and triangles prevent it from being too fragile. The first variation, brown with brilliant orange spots, is based on a female Chalk Hill Blue—they really don't have much blue in them. The pink colorway is purely imaginary.

VARIATIONS

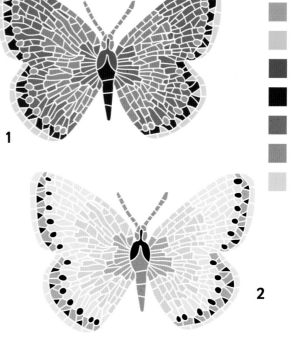

1

2

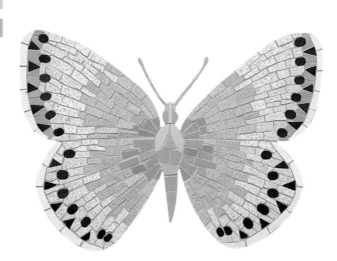

Gem Butterfly

This jewel-like butterfly is encrusted with glass "gems" that are set in the melee of bright colors. Note how they reflect light, adding to the rich effect. There are many different hues at work here, with a stark dark and white trim to the wings, but the palette remains well balanced. In other words, it works. The different areas within the wings are divided by colored stripes. The round "gems" interrupt the flow of the background tesserae, but these tesserae have been carefully selected to fill the spaces between the "gems," thus eliminating any awkward spaces in the design. One variation tries a different mix of bright colours, while the other illustrates a more muted blend of similar tones and hues to create a different mood entirely.

VARIATIONS

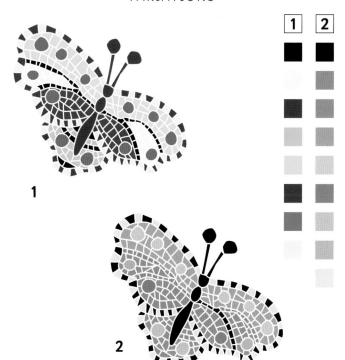

1

2

The wing tesserae flow out directionally from the body, and are occasionally interrupted by glass "gems."

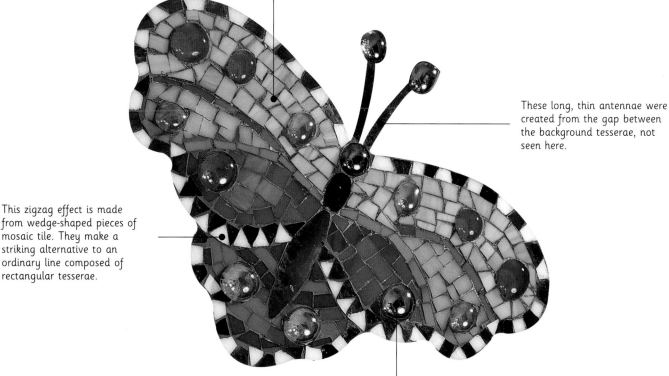

These long, thin antennae were created from the gap between the background tesserae, not seen here.

This zigzag effect is made from wedge-shaped pieces of mosaic tile. They make a striking alternative to an ordinary line composed of rectangular tesserae.

Rounded glass pieces have been used to excellent effect in this motif; evenly dispersed around the butterfly, they have become an integral part of the piece.

Dragonfly

The mottled gray and white tesserae used on the wings of this dragonfly give them a light, semi-transparent look. The long, thin body, by contrast, appears much more solid, due to the use of a deeper color. A rounded, three-dimensional effect is achieved by adding curved black stripes. As an alternative to the ephemeral look, both of the suggested variations are based on intense colors, although their treatment differs. The first uses sharp, twinkling colors, whereas the second has a warmer feel.

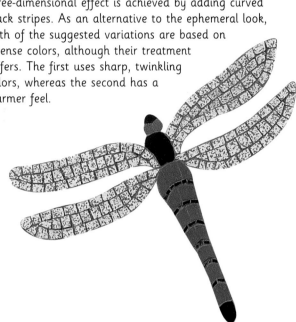

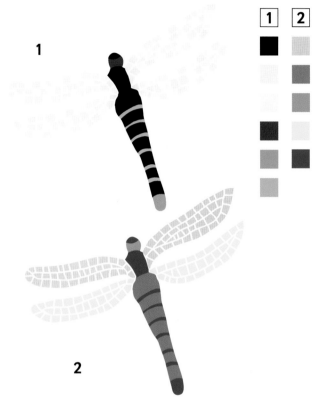

Classic Dragonfly

Beautifully balanced tonally, this classic dragonfly mosaic depicts light, fluttery wings, by using pale and varied tesserae, and a darker body and head in more solid colors. Note how the legs are more shadowy when seen through the wings. A mix of bright hues on one variation creates a fun alternative, while the green slant on the second colorway gives it a more natural look.

VARIATIONS

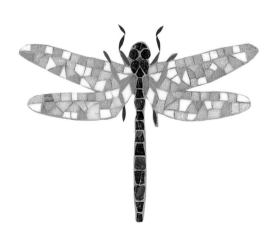

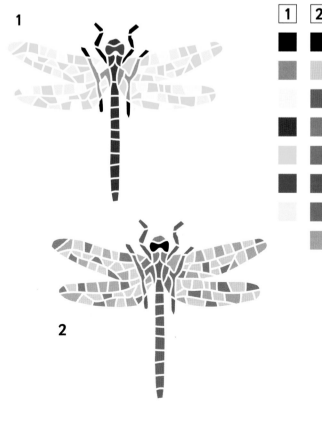

Bee

This bee is a simple, but powerful little motif, using, as it does, just three tones: black and white, with yellow in between. Notice how few tesserae are used: just one for each of the wings, each stripe, and each section of leg. The tesserae have been individually shaped to great effect. The variations are not quite as stark: the first uses two pale shades for the wings, and three colors on the body and legs, while the second variation swaps the black for a deep red and brown.

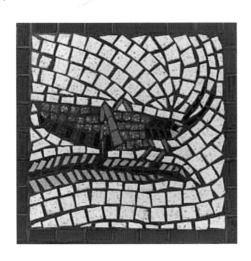

VARIATIONS

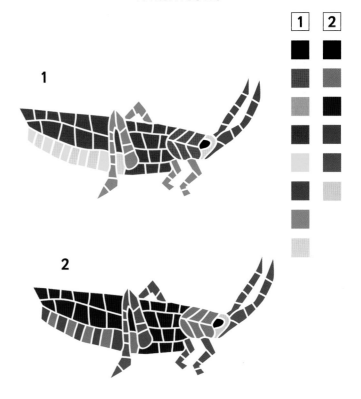

Grasshopper

The charm of this grasshopper mosaic lies in its sheer simplicity. The tesserae follow the body form horizontally, and this is broken up by the vertical zigzag of the legs. The abdomen seems to emit a faint glow as the red works against the complementary green. The alternatives offer different directions, one into a more dramatic realm of bright colors, the other utilizing subtler, naturalistic browns.

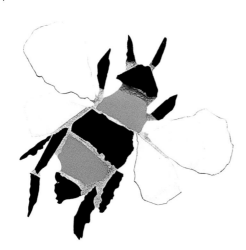

VARIATIONS

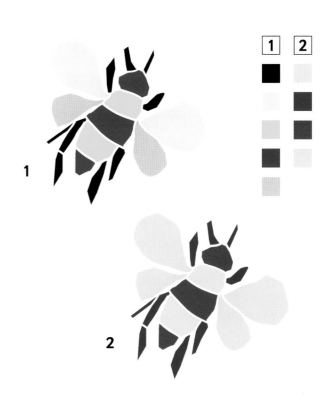

INTO THE DEEP

Fish provide one of the most popular themes to be found in mosaic art, from ancient Roman bathhouses to modern-day swimming pools. Their streamlined contours are endlessly satisfying, and the sheer variety in size, shape, and color gives much scope to the imagination. They can range from muted, subfusc tones to exotic tropical hues, and gentle, flowing curves to spiky and complicated forms. The portrayal of water furnishes the mosaicist with plenty of opportunity to explore the possibilities of the andamento. For example, a horizontal pattern such as opus tesselatum can give the impression of calm, still, depths. More wave-like lines can be introduced to show moving currents, or directionless opus palladianum can imply choppy, restless water.

Fish can often be found in Christian mosaics, representing Christ or his followers. The Romans were responsible for beautiful mosaics in bathhouses, crowded with many different sea creatures including whales, swordfish, eels, octopuses, and, in particular, dolphins, which were associated with virtue and also safety at sea. Seashells and jellyfish featured as well, and these are also popular today. Spiral shells can be tricky to construct, as the mosaicist has to ensure an ever-tightening curve that is diminishing in width at the same time, while lobsters and crabs are decorative, complex shapes and provide lots of fun.

Salmon

A studied use of tonality, rather than changes in hue, gives this mosaic its atmosphere, as if the gleaming salmon is hanging, almost motionless, in a ghostly fashion. This mosaic was built up from different colored pieces of Westmorland slate, shaped with tile nippers. In the first color variation the flecks of red on the salmon's body add a little drama. The second colorway of cool blue, gray, and lilac retains a smooth, mysterious quality.

VARIATIONS

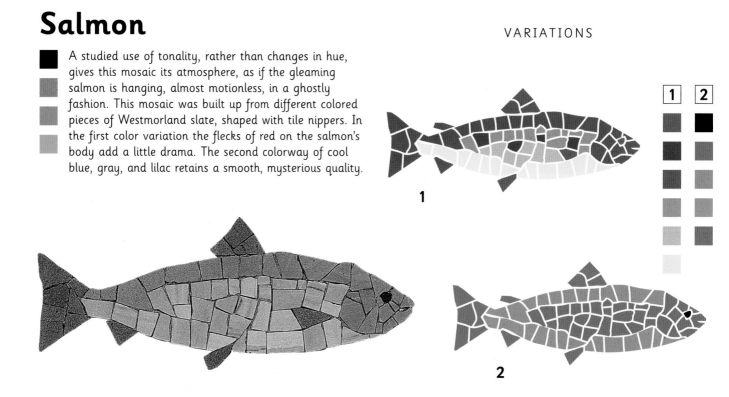

1

2

Fish

This sleek, gleaming fish makes full and decorative use of rich bronzes and golds. The tesserae are carefully cut to exploit the overall curved effect. For something altogether more colorful, try using bright, almost acid colors, or combine a few natural, earthy shades and liven them up with blues and reds.

VARIATIONS

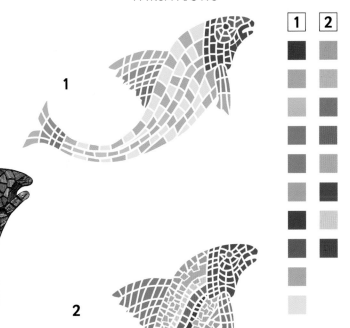

1

2

Exotic Fish

This beautiful fish is composed of only a few tesserae, but they work extremely hard and the curves of the fish are not sacrificed in the process. The colors used vary dramatically in tone—black and white, for example—and different hues are also utilized, so there is a lot going on. The alternative suggestions follow the same formula, few tesserae and plenty of color interest.

VARIATIONS

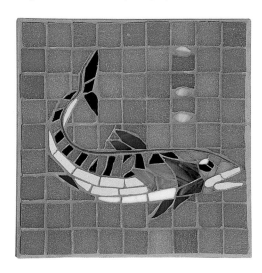

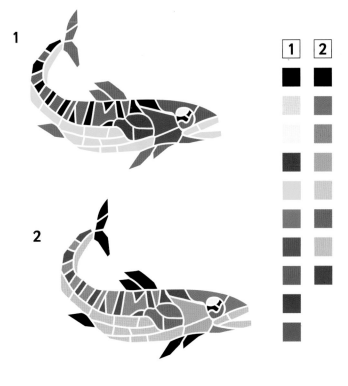

1

2

Tropical Fish

Tropical fish are often very colorful, and what makes this fish mosaic particularly convincing is the variegated use of color as is often found in the real thing. This means that there is a lot going on, but it all manages to work together. The motif was made using large pieces of tile, some of which had a color change within the tile itself. The fins are well defined by contrasting striation, and dramatically radiate away from the fish's body. The black and white in the fins is repeated in the central horizontal stripe that divides the body. Above this stripe are warm browns that give the fish some weight, while, below, the pale underbelly gleams eerily. With so much variety within one mosaic, it is interesting to note how the gray grout has a unifying effect. The two variations also use plenty of color, although one has a predominantly green look to it, while the other is based on a blue palette.

VARIATIONS

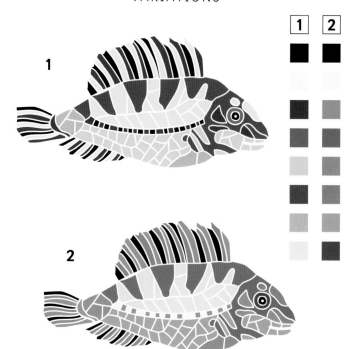

The thin stripes of the fins contrast with the large tesserae that make up the body.

These stripes indicate the multiple gill openings; but they also link the upper and lower parts of the body with their warm reddish-brown color.

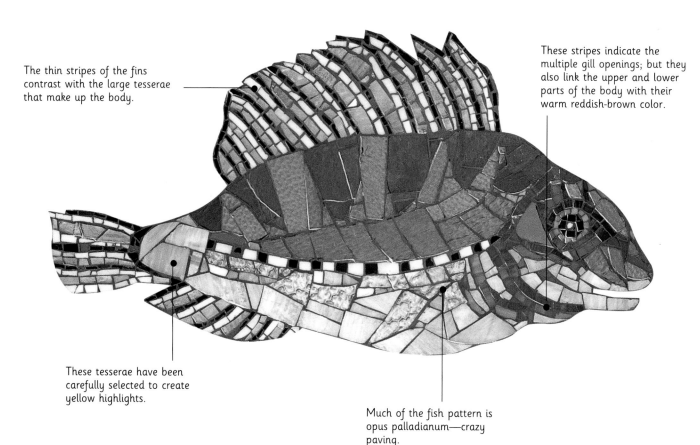

These tesserae have been carefully selected to create yellow highlights.

Much of the fish pattern is opus palladianum—crazy paving.

Ocean Fish

Patterned china has been used in this mosaic to help
give it texture. Here, only a few different hues have been
used, just some blues, two yellows, and white. The
drama comes instead from the juxtaposition of light and
dark shades: deep blue against pale blue, yellow, and
white. The variations use a more extensive palette,
although they still pitch dark colors against light.

VARIATIONS

1

2

Diving Fish

This fish is full of electrifying drama as it plunges to the
depths of the sea. Its marvelous spiky fins are strikingly
dark against the bright, hot hues of its body. The two
variations maintain the formula of dark-toned fins
against a contrasting body color, greens in one and
blues in the other.

VARIATIONS

1

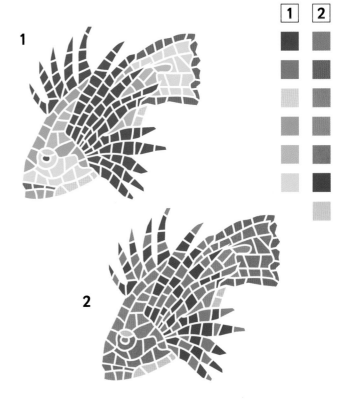

2

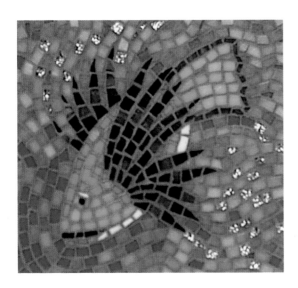

Angel Fish

■ Large, individually cut tesserae emphasize the flatness of this fish's body. The stripes are bold and well balanced, the blue contrasting with the yellow, and the black provides a tonal contrast that enlivens the composition. Tropical fish motifs, such as this one, provide a great opportunity to have fun with bright colors, and both the variations take advantage of this fact.

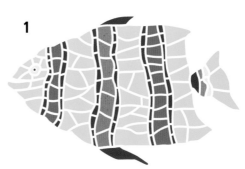

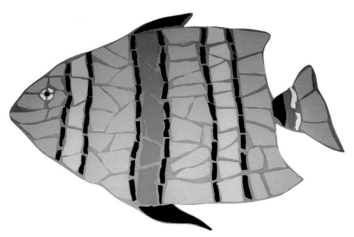

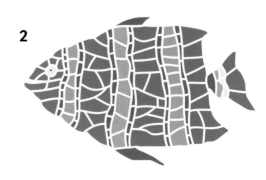

Dolphin

Dolphins have long been a favorite theme of mosaicists, and this one is a classic, taking full advantage of the beautiful, smooth dolphin shape. The back of the dolphin uses mingled shades of brown, and this adds interest as it contrasts with the flat, creamy underside. The red detail gives an unexpected fillip to the whole, and the scheme is retained in the two variations that use alternative aquatic colors.

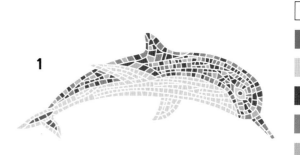

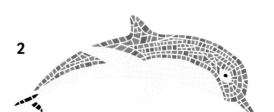

Swimming Turtle

An interesting use of different hues that are similar in tone produces a busy effect in this mosaic, as if you are looking down on the turtle through choppy water. The andamento smoothly follows the shape of the turtle's legs; but for the shell you have to take a closer look to analyze the pattern, such is the variety of tone and hue employed. In the yellow variation more tonal differentiation is evident, whereas the second variation is more even.

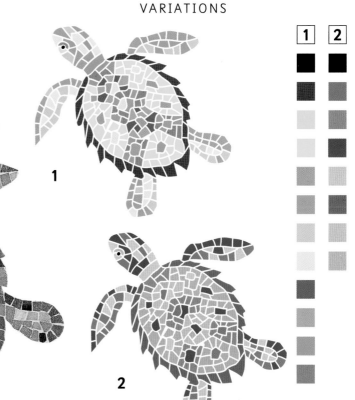

VARIATIONS

Turtle

This turtle mosaic is composed of a variety of materials to charming effect. The soft blue balances well with the golden brown, enhancing the decorative pattern of the shell. One suggested variation contains a cooler, sharper mixture of blacks and greens, whereas the other uses a much warmer palette of yellows, reds, and browns.

VARIATIONS

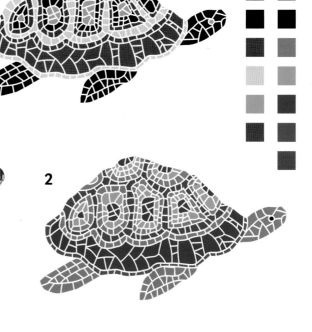

Stylized Seahorse

The intricate shapes of these gorgeous little creatures provide lots of scope for imaginative use of shaped tesserae and color. The inspired use of triangles on the body and tail adds to the decorative quality, while flashes of bright color add interest. The long streaks in the middle can be made of smaller tesserae, but try to keep that sharp swerve. The colorful variations are great fun; we are not interested in realism here!

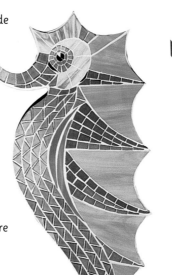

1

2

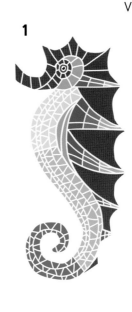

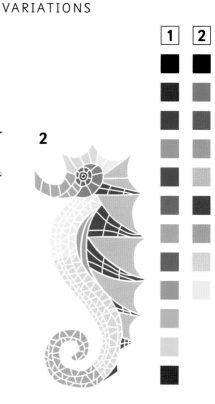

1 2

Classic Seahorse

An interesting dichotomy is expressed in this seahorse mosaic; although the colors are very gentle, the tesserae look quite jagged. These jagged pieces produce a beautiful sweeping curve from the neck down to the tip of the tail. At the opposite extreme, the first variation mixes strong, contrasting colors, while the second alternative is a little more restrained, yet still colorful.

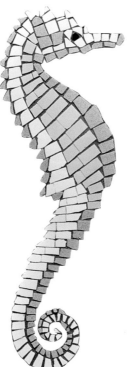

1

2

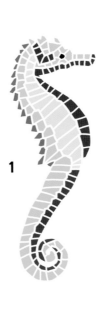

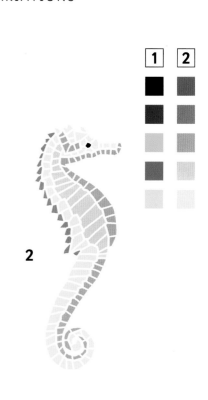

1 2

Seashell

Naturally soft, gentle shades on this seashell mosaic are strengthened by deep red touches. The andamento is very expressive here, caressing and complementing the rounded structure of the shell. The first alternative version utilizes lots of murky, mollusc-like greens, while the second variation uses much warmer colors. In each variation the subtlety of the original is retained.

VARIATIONS

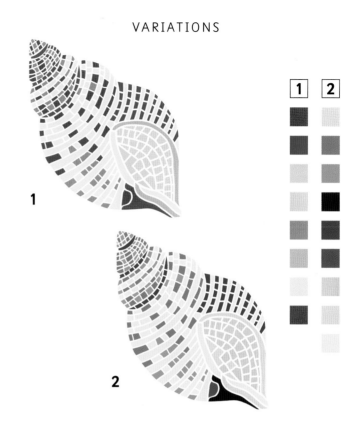

1

2

1	2

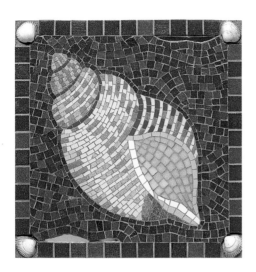

Fan Shell

Constantly changing colors along the spines of the shell are an interesting feature of this mosaic. The device creates a subtle effect that draws the eye. Note also the clever trick at the base of the second and fourth spines: a background tessera is substituted to avoid a sense of overcrowding at the confluence of the spines. The alternatives offer one version similar to the original but slightly pinker, and one in sea-like blues.

VARIATIONS

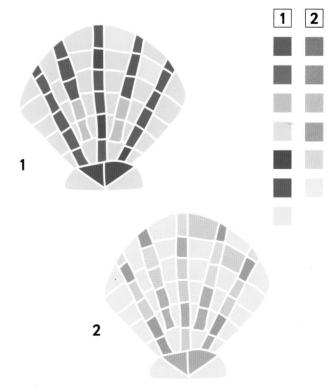

1

2

1	2

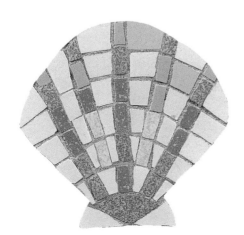

Conch Shell

The soft curves on this shell have been augmented by defining inlaid strips of metal. Within these lines there is less work for the tesserae to do, rather they can concentrate on portraying the directional flow from the base of the shell to the tip. The many dusky colors used are highlighted by gleaming streaks of white that make the shell look wet and slippery. Notice how the lines of tesserae caress and fill out the curve of the main section, while gradating from dark tones on top to slightly lighter colors lower down, as if the light is being reflected off the seabed. The two alternatives also use plenty of colors, but remain tonally faithful to the original.

VARIATIONS

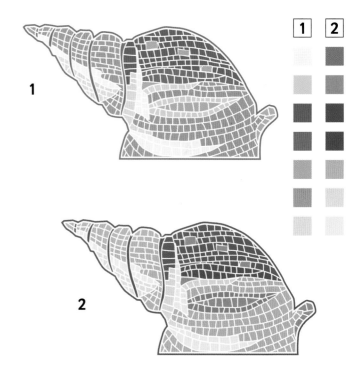

Strips of metal help to define and enhance the coils of the shell.

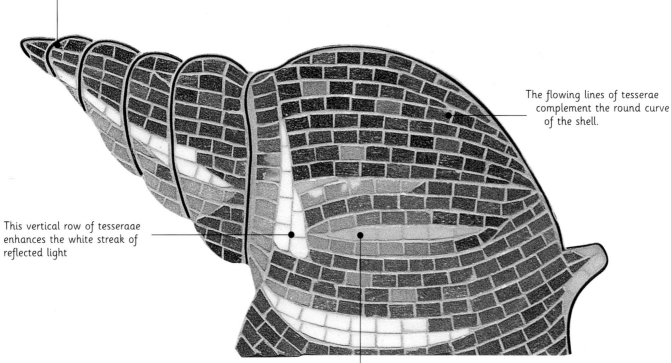

The flowing lines of tesserae complement the round curve of the shell.

This vertical row of tesseraae enhances the white streak of reflected light

Little streaks of yellow add variety and interest.

Starfish

■ This starfish mosaic has beautiful waving arms depicted in muted coloring. Note how the rounded "dot" tesserae enhance the decorative effect; a bit of a fiddle to cut, but well worth it. The two alternative colorways go in completely the opposite direction, with eye-opening hues in one, and sharp tonal contrast in the other.

VARIATIONS

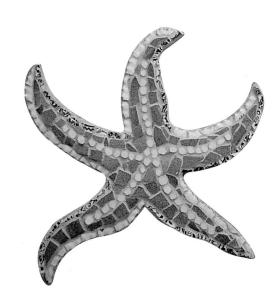

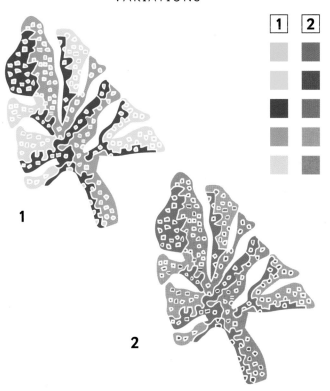

1

2

Coral

This coral mosaic has a marvelous, otherworldly, underwater presence, exotic and remote. The outline contouring this complex shape is important in creating its sense of presence, combined with clever alterations in tone and hue to give the piece form. The complementary hues employed are very suggestive of the extraordinary color combinations to be found in the ocean. The two variations use different palettes but both aim for unexpected color contrasts.

VARIATIONS

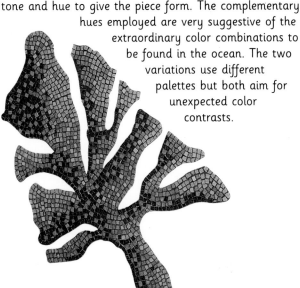

1

2

Lobster

The complexity of a lobster's form is successfully portrayed in this mosaic. The blues, in opus palladianum, form the body, legs, and claws, while the contrasting red, orange, and white define the details and have some directional movement. The same formula is used in the variations, either by pitching ultramarine against murky greens, or contrasting the traditional pink and red against black.

VARIATIONS

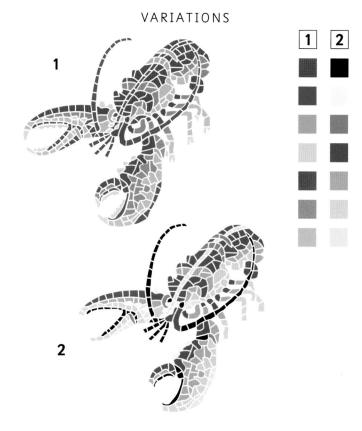

1

2

1 2

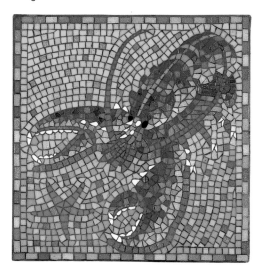

Classic Lobster

An intricate lobster mosaic makes good use of gradated reds and oranges: they have a unifying effect on this motif, as does the gray grout. The tiny flash of white on the claws draws particular attention to them. The two suggested variations have strayed into an alternative reality, but underwater themes do tend to suit a fantasy treatment.

VARIATIONS

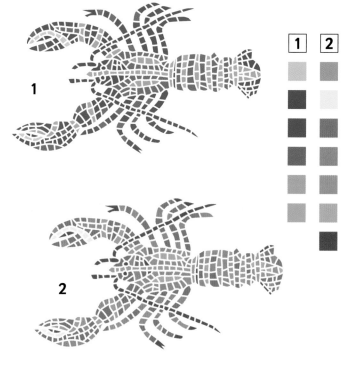

1

2

1 2

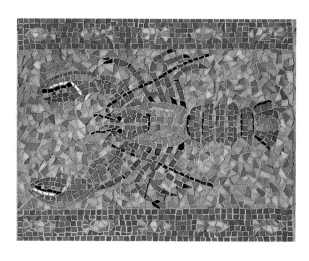

Crab

Viewed from above, this crab mosaic is a classic example of how a good silhouette can "tell the story" practically on its own. It is decoratively laid out and easy to understand visually. The colors are held together by a blue-green theme, the shimmering detail of the gold smalti adding mystique. The variations are also kept to a unifying color theme, with cool blues and purples in one and warmer browns and pinks in the other.

VARIATIONS

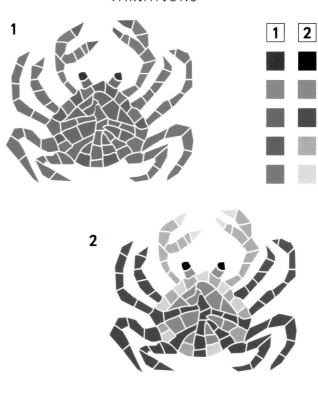

1

2

Classic Crab

Crabs may be regarded in some parts of the world as evasive and deceitful because of their sideways walk, but this particular crab is quite forthright. The red used is powerful and the body well described by the decreasing "rings" of tesserae. In the variations, the use of graded colors give the crab more form, with speckles of highlighted color for interest.

VARIATIONS

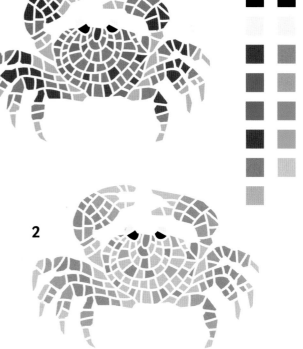

1

2

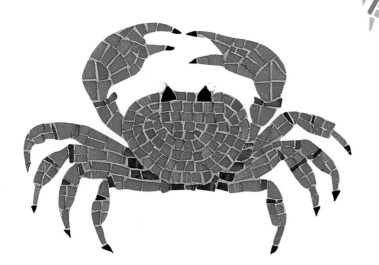

BOTANICAL BEAUTIES

Flowers and foliage have always influenced mosaic design. Sometimes they are presented in a naturalistic way, often, however, they are simplified and stylized until they become almost abstract. Sometimes they make up the main subject of a mosaic, but frequently their role is as additional, decorative material.

In Alexandria, typical mosaics show the flora found along the banks of the Nile: beautiful lotuses, reeds, and papyrus, indicating an ancient Egyptian influence. Grapevines are a commonly found motif for mosaics: the Romans were fond of them because they celebrated wine and good times; later Christian mosaics used them to symbolize the blood of Christ. Ivy is also often found in Roman mosaics. It was sacred to Dionysus, god of wine, and thought to cure drunkenness when worn as a garland. Both the grapevine and the ivy have decorative leaves and wonderful trailing stems and tendrils that translate well into mosaic.

Flowers can be simple or sophisticated. Daisies and sunflowers are popular subjects today, the latter being increasingly associated with environmental causes. Early mosaics often show a stylized form of lily: the Romans linked it with the goddess Juno, and it is also the emblem of the tribe of Judah.

The Tree of Life is also a favorite subject for mosaic, and is a motif significant in many cultures around the world. The tree links heaven and earth, and represents the nurturing and sheltering power of nature.

Flower Symbol

Stylized flowers such as this one are found all over the world: a universal motif. This brown mosaic version is fairly stark, but has a traditional feel. The violet and yellow alternative makes use of complementary colors to give it a little pizzazz, while the blue version is designed to be slightly softer and prettier.

VARIATIONS

1

2

1 2

Water lily

A sense of tranquility surrounds this mosaic water lily, with its creamy white petals and pale yellow stamens. The petal tesserae are individually shaped, making it more difficult to construct than it may at first appear. The yellow and orange variation is bright and has lots of energy, whereas the pink alternative maintains more of the calm and gentle purity of the original.

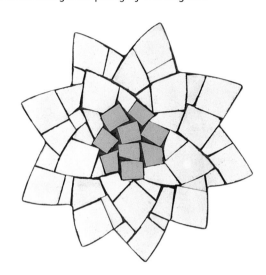

VARIATIONS

1

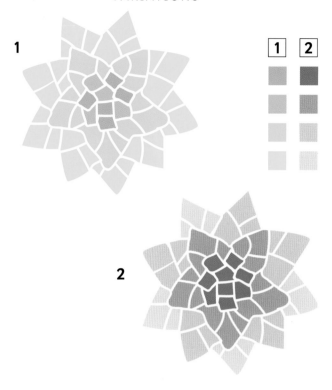

2

Patchwork Flower

Broken patterned china has been used in parts of this flower mosaic, making it reminiscent of a patchwork quilt. Because of its simple, symmetrical design, this motif works well with endless color variations. Various tones of a single color could be used to put a little asymmetry into the petals, as the red first variation illustrates. The second alternative has cool blue petals but a warm heart.

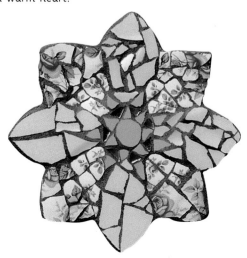

VARIATIONS

1

2

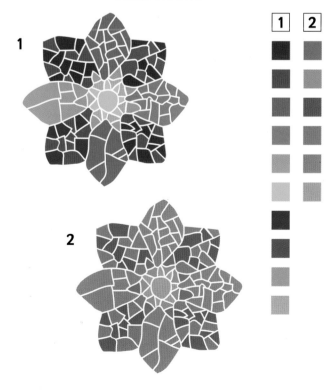

Flower Sprig

A well-balanced flower sprig mosaic is made up of warm greens and pinks, colors that are beautifully chosen and graded. The first variation uses colder, bluer greens but mixes in some yellow with the pink petals to compensate. The second variation confines itself to the use of muted greens and blues.

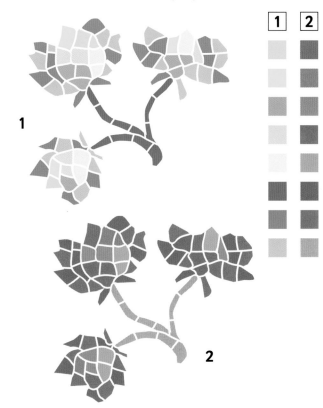

1

2

1	2

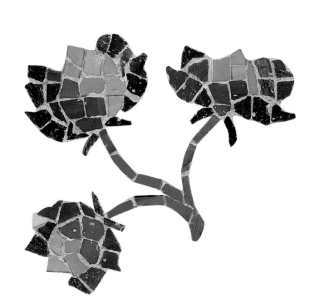

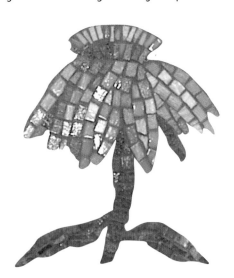

Open Flower

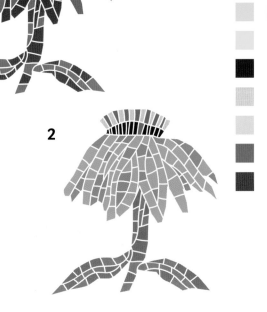

A flower motif with drooping petals makes excellent use of color contrasts. Here, the rich orange and yellow stamens zing out against the mauves used in the petals and are separated by a neutral gray. Lemon stamens contrast with deep red petals in the first variation, while the second colorway reverses the tonal contrast, juxtaposing dark stamens against brighter petals.

1

2

1	2

Daisy

Yellow grout, used in this daisy mosaic, gives it a charming, pollen-dusted appearance and helps to unify the petals and the yellow center. Daisies come in many sizes and colors, and the suggested alternatives include one "hot" version with orange petals and a dark center, and one in fresh pastels. Why not adapt the color of the grout accordingly? Try a reddish grout on the orange petals, or soft pink on the pale blue ones.

VARIATIONS

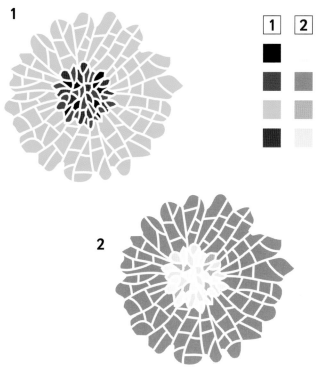

Bell Flower

A bell-shaped flower fits neatly into the space of its arched stalk to form a pleasing, self-contained motif. The colors used are intriguing: the cold blue stamens and the blue-green sepals contrast with the warm purple and orange-brown of the flower and stamen filaments. The variations both retain the green stalk and leaves, but try out some different hues on the flower.

VARIATIONS

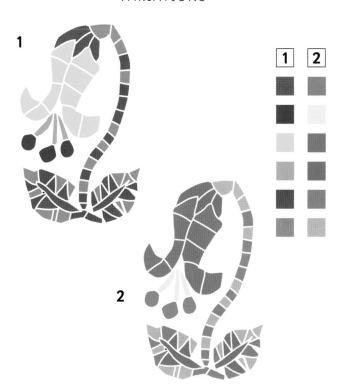

Stylized Flower

The tesserae that make up this stylized flower mosaic have been prettily shaped into individual petals. It looks a little like a small fire with leaping flames. In the suggested variations there is more variety of color among the petals; they both use a warm color at the heart, but the first contrasts this with many different blues while the second uses gentle pinks as an alternative to the cool mauve of the original.

VARIATIONS

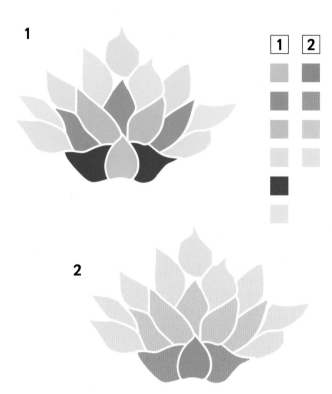

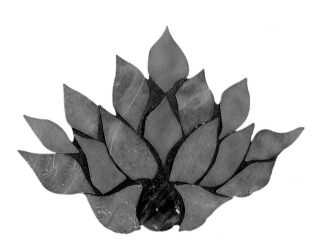

Tropical Flower

The tesserae that make up the petals of this flower are cut in long streaks, and the dark grout not only adds to the hot, exotic impression but also echoes the veining found in flower petals. The contrast in color in the stamens adds a piquancy. The variations suggest a darker, rich purple alternative, and a lighter blue one that is a little cooler.

VARIATIONS

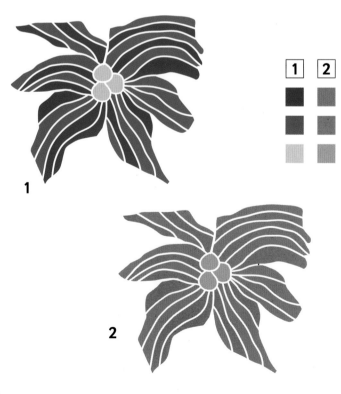

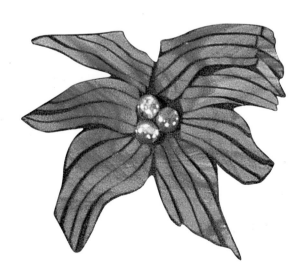

Funky Flower

This flower shows how effective a simple approach can be. The tesserae are roughly cut, but it doesn't matter as they have been confidently placed to build up the different shapes. The tesserae are quite widely spaced, but again this works because of the boldness of the colors. Note the little heart-shaped piece charmingly slipped in among the petals. The variations show a yellow flower and a blue one.

VARIATIONS

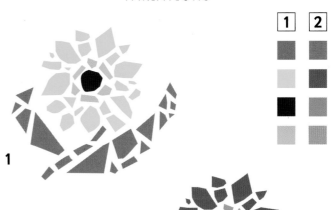

1

2

The use of black at the heart of this flower provides a strong focus for this stylized mosaic.

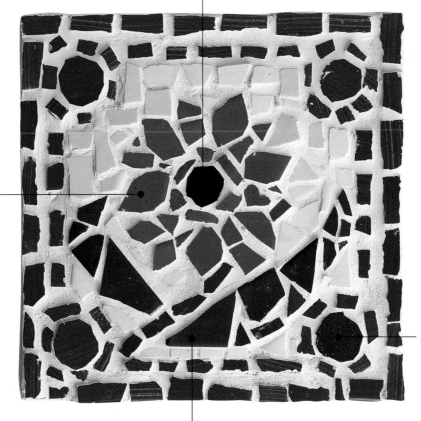

Bold use of color is probably this motif's most defining feature—all the tesserae, except for those used in the background, have a strong hue.

Simplified flower motifs form the corner points of the blue border. The tesserae for the leaves of the main flower motif neatly work their way around the border.

Chunky tesserae give a strong dimension to both the leaves and petals of the flower.

Vine Leaf

The popularity of the vine motif goes back to the Roman era, and it often crops up in ancient Roman floor mosaics. The shape of the leaf, with its deep curves, needs careful construction and individual cutting. The coloring of the original has an autumnal feel, but you could also employ summery greens, or try something completely different with rich aubergine and rust colors.

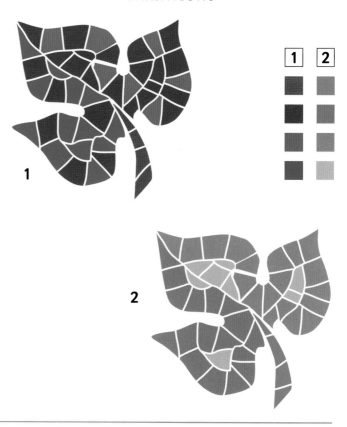

1

1 | 2

2

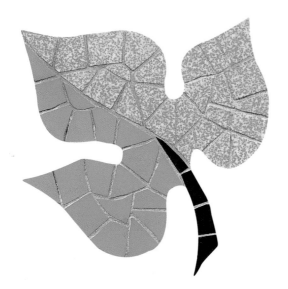

Oak Leaf

This leaf shows how the tile interstices can be used to maximum effect: they display the pattern of the veins beautifully. Although there is no outer defining line of tesserae, the edge pieces create a clear and smooth contour. Experimenting with this motif gives you a great opportunity to exploit the large palette of greens, and also to introduce a few autumnal hues.

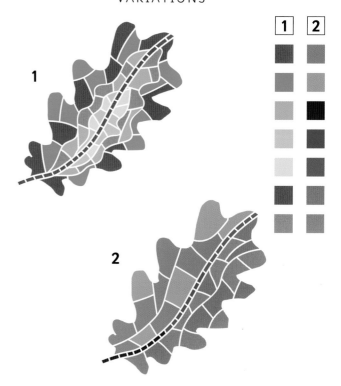

1

2

1 | 2

Falling Leaf

This leaf mosaic has a lovely jaunty curve to it, with a winding inner shape reminiscent of an oak leaf. Note how the first line of pale tesserae that surrounds this inner shape faithfully follows it around. The result is very decorative. The dark part of the rim defines the main shape, and balances well with the deep blue-green inner shape, while the red stem adds an intriguing glint. The two variations suggest more autumnal color schemes.

VARIATIONS

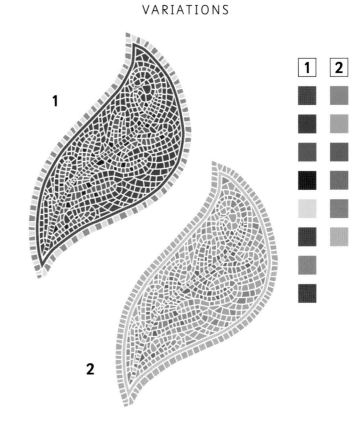

Skeleton Leaf

Picked out in a decorative green, this spiny leaf mosaic has a lovely, graceful curve and is not hard to construct since it consists of single lines of tesserae. It is important to establish the central stalk as an anchor point before adding on the side spines. The two variations use graded colors that create a different mood. One changes from side to side, the other from bottom to top.

VARIATIONS

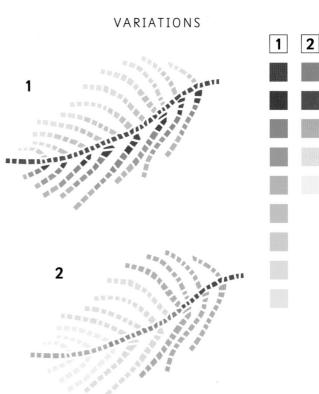

Framed Leaf

A simple, graphic motif, this mosaic is reminiscent of a woodcut. Its strength lies in its clarity; just two colors are used. Note how the background tesserae echo the form of the leaf, adding a sense of movement. The variations retain the two-color theme, although the first mingles closely related tones within those two colors to add a little depth. The second alternative reverses the distribution of dark and light.

VARIATIONS

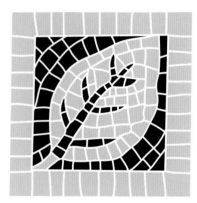

1

1 2

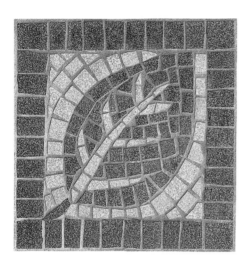

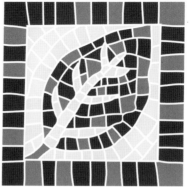

2

Horse Chestnut Leaf

The beautiful organic shape of this horse chestnut leaf mosaic has been made using comparatively large tesserae to build up the complex shape of the motif. This technique gives the piece body and energy; it is far from wispy and delicate. The alternative colorways suggest deeper greens and the rust colors of a fall leaf.

VARIATIONS

1 2

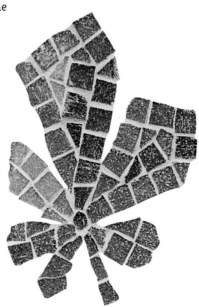

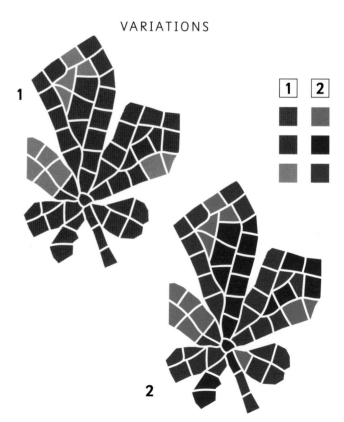

Cactus

This cactus has a hot, Mexican look to it, as it bakes under the relentless sun. The greens of the cactus contrast well with the pimento- and cayenne-colored backdrop. The blue flower adds a sharp note of interest, which is again picked up in the border: a dark tone that holds the composition together. The variations show a light green cactus, while the other is burned red.

VARIATIONS

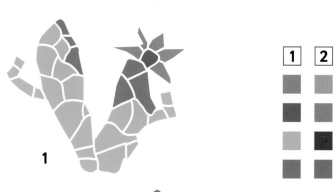

1

2

These lines of tesserae introduce a sense of movement to the mosaic as they ripple out from the sun, echoing and emphasizing the round sun.

The use of large, sharp-edged tesserae in opus palladianum emphasizes the prickly nature of a cactus.

A bright flower, whose color is repeated in the border, softens the overall intensity of this mosaic.

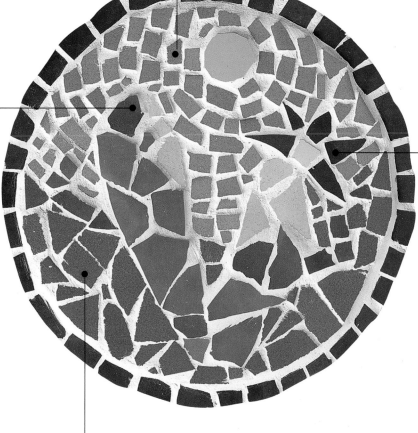

The orange and yellow of the background create a hot and arid desert scene.

Swaying Tree

Trees can be adapted in many ways as mosaic images. This one has been given quite a plain color treatment, but the main interest lies in the andamento, which is full of movement and suggestive of billowing leaves swaying in the breeze. This design also offers great potential for mingling several colors, to give the impression of leaves fluttering and catching the light. Possible color variations include summer and fall versions.

VARIATIONS

1

2

Tall Palm

Three different patterns make up this palm tree: the leaves, the coconuts, and the trunk. In each the tesserae have been specially shaped; the overall effect is rich and ornamental. Although the colors do not vary a great deal tonally, the green of the leaves is complementary to the reddish-browns of the rest of the tree. This adds piquancy and balance. The first variation suggests a palm tree at sunset, with deep, dark hues, while the other stays with more earthy shades.

VARIATIONS

1

2

Lemon Tree

Lozenge-shaped tesserae form both the leaves and lemons in this tree mosaic. The lemons are evenly distributed, and although both the yellow and green are good, strong hues, they still contrast tonally with each other. The first variation has turned the lemons into limes and used greens that vary in both warmth and brightness, but are all light tonally. The second uses only two tones of green and some very pale fruit for a simple and dramatic effect.

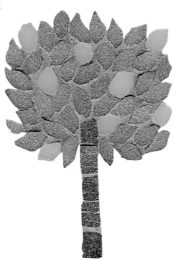

VARIATIONS

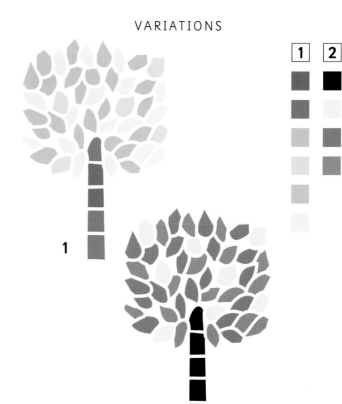

Fruit Tree

The leaves on this tree are all individually cut lozenges, and they have been informally laid to create a natural, leafy effect. The tree appears to be on fire: on one side the leaves are green and the trunk is brown, on the other the tree is blackened and charred and red flames are taking hold. One variation has orange leaves and blue flames scattered throughout (like a gas fire!), and the other vice versa.

VARIATIONS

SYMBOLS, BORDERS, & PATTERNS

The mosaic medium is ideal for building up repetitive patterns that are deeply satisfying examples of visual logic. They don't have to be complicated: sometimes the most effective contain just two colors. The mosaicist should be aware, however, that any repeating pattern will need careful measuring out before starting.

Some patterns are composed of obvious and recognizable motifs, such as a wave or a lotus flower. There are also universal symbols found all over the world: the sun, for example, or the spiral, which represents masculine and feminine energy. Other patterns are purely abstract; these non-figurative designs are important in Islamic cultures, where figurative images are considered irreverent. Some abstract ancient mosaics have a three-dimensional effect and look startlingly modern, reminiscent of psychedelic or pop art.

Borders play an important part in framing a mosaic, and can be simple or elaborate. A sophisticated, decorative border can be the "main event" itself—a mirror frame, for example, or a strip that runs around a room. Lines of tesserae can be used to create delicate ribbon effects, ropes, plaits, and decorative knots.

The Romans occasionally introduced lettering into their mosaics. Perhaps the name of the donor who funded the mosaic, or if a mosaic map needed labeling. Sometimes religious texts became part of the design. Letters and numerals can be very successfully carried out in mosaic because they have a powerful graphic appeal and make tough and decorative house names and numbers.

Guilloche Knot

■ This motif has a Celtic look, although it is based on a Roman design. The color combination retains a traditional feel, but the motif works equally well when given a modern spin by using citrus colors or pastel shades encased by black.

VARIATIONS

1

1	2

2

Celtic Symbol

This Celtic motif combines different sizes of tesserae. Lines of small tesserae define the shapes and larger, specially shaped pieces fill the spaces, including some beautiful blue-gray slate. Alternatively, these areas could be filled with smaller tesserae. The original mosaic employs closely related colors, whereas the variations illustrate a wider spread of colors. In each case the linear element is kept strong.

VARIATIONS

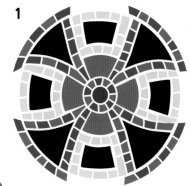

1

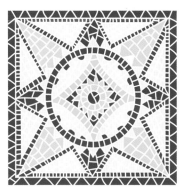

2

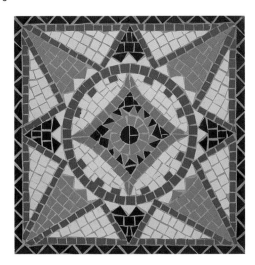

Geometric Star

Carefully cut and positioned tesserae and beautifully balanced coloring are the main features of this star motif. The black is strong but not too heavy, contrasting tonally with the lighter tones, while the central flower shape juxtaposes blue and yellow hues, again set off by the light background. The alternative versions strive to maintain this tonal balance, but suggest different, brighter hues.

VARIATIONS

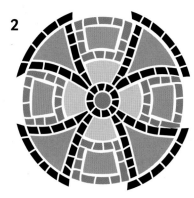

1

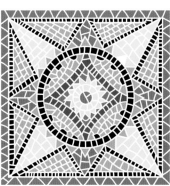

2

Spiral Panel

The ancient appeal of the spiral has been enhanced by an interesting detail in this motif; the addition of the little spines built on at intervals, breaking up the curving rows of tesserae. Some of these mini spines vary in color from the main spiral, and this, again, adds a little extra to an otherwise simple design. The two variations do likewise, and, although differing entirely in mood due to the color choices, they remain faithful to the formula.

VARIATIONS

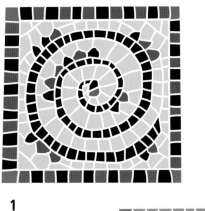

1

2

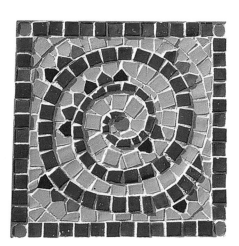

Fleur-de-Lis

The fleur-de-lis symbol is based on either a stylized lily or an iris; you can decide for yourself. As well as being the emblem of French royalty, it also represents the Trinity. Here, the treatment of this decorative motif utilizes tonal differences, with the pale areas providing highlights against the dark body of the emblem. The two variations use more color: one in strong hues, and the other more delicate.

VARIATIONS

1

2

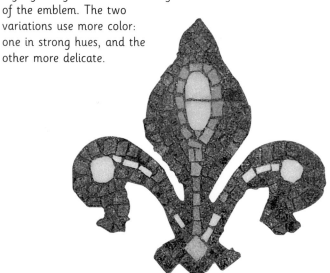

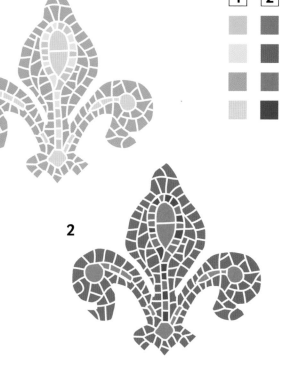

Geometric Flower

In this motif, strong colors are successfully distributed over a pale background, the whole being bound together by the dark border. The first suggested variation uses dark purple instead of black for the border, and employs some fairly acid hues as a change from the earthy colors of the original. The second variation contains contrasts in both hue and tone.

VARIATIONS

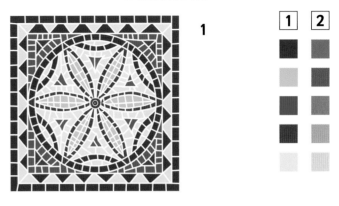

1

2

Star

Yellows and complementary blues are pitched against each other in this eight-pointed star. On first glance, the rim appears to be part of the blue areas, but by using the darker blues and introducing some red tesserae a defined border is created. The star is mainly opus palladianum: a good solution for a tricky shape. The variations suggest a cold star using several shades of blue, and a hot star using browns and pinks.

VARIATIONS

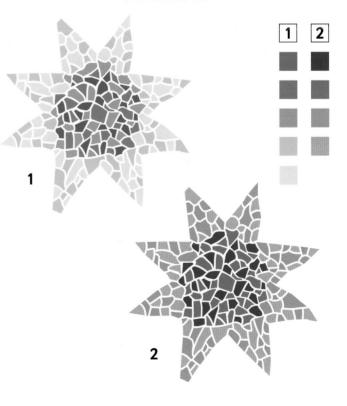

1

2

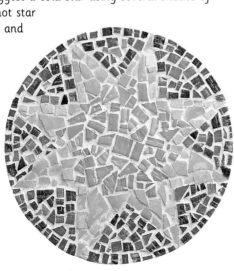

Sun Disk

This sun mosaic is fierce and full of drama, contrasting light and shade with imaginative use of color. The direction of the surrounding tesserae—flowing out from the sun—gives the impression of glare and flying sparks. The first variation features an equally merciless sun in dazzling yellows set in a deep violet sky. The second, orangey sun is a little less violent, although it still throws out sparks.

VARIATIONS

1

2

1 2

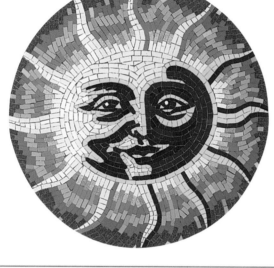

Sun Motif

Using dark tones against bright colors will usually make them seem even brighter, as this sun motif mosaic illustrates. The blue against the yellow enhances the brightness of the whole effect and makes the image sizzle. The same idea is borrowed for an orange and purple variation. Alternatively, cool blues can be used to frame a pale but bright sun.

VARIATIONS

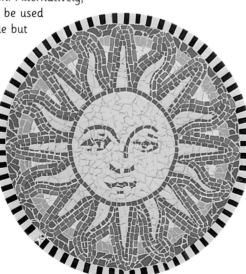

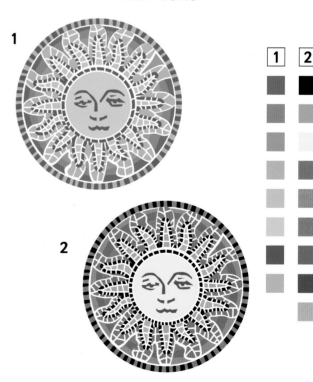

1

2

1 2

Sun Mosaic

A baleful glare beats down from this powerful sun mosaic. A strong outline around the eyes and the rays, interlinked with wild, hot colors, some light and some dark, add to the tempestuous confusion. The variations offer flaming oranges and purples, and white-hot yellows bordered by deep red.

VARIATIONS

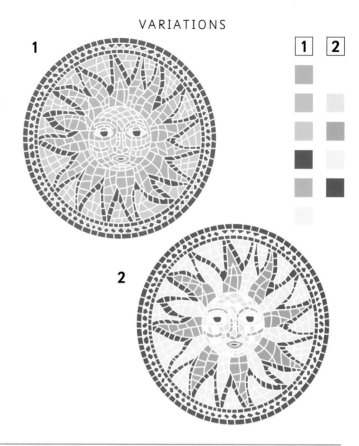

1

2

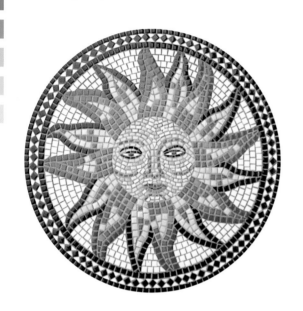

Moon

The upward curves of the mouth and eyebrows create a knowing expression on this moon. Note how the colors beautifully graduate from the purples and mauves at the edge of the motif to the delicate pale blues further in. The tesserae curving around the moon's eye give it a world-weary expression. The variations maintain the gradation of color and tone, one based on yellows and oranges, the other on pink.

VARIATIONS

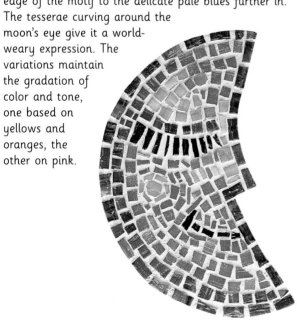

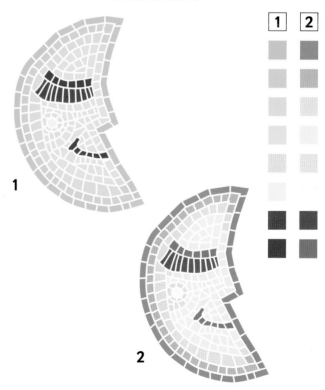

1

2

Floral Border

Mosaics can be influenced by designs found on textiles, as this repeating border motif was. The design has an Oriental flavor, and offers scope for a varied use of color: because the individual motifs are slightly separated it is easier to successfully mix and match different colors. Note how well the combinations of blue and red, green and purple, and orange and pink work in each of these examples. Bear in mind that many of the tesserae need shaping individually, so this border can take time to produce.

VARIATIONS

1

2

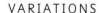

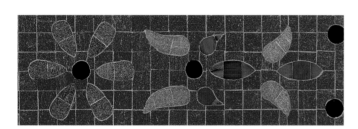

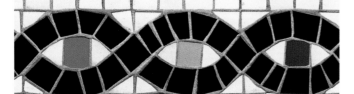

Twist Border

This simple but effective twist makes a lively border. It looks especially good on a floor, or on any mosaic that covers a large enough space to feature a number of twist motifs. You can choose to execute this design using a dark twist on a light background, such as the brown against cream used here, or the dark blue contrasted with lighter pink around it in the second variation. Alternatively, consider a light twist on a dark background, as in the first color variation that features a light green twist on a darker blue background.

VARIATIONS

1

2

Stepped Border

This border is made up of whole, half, and quarter mosaic tiles, and is quite easy to make. It is a classic motif that can be treated using traditional colors, such as the earthy red, black, and white used here. Four colors could also be used. The sand, terra cotta, and two shades of blue—one slightly "warmer" than the other—used in the first variation combine to create a lively effect. In the second colorway a completely different treatment uses soft browns and beige.

VARIATIONS

1

2

Triangle Border

Using whole mosaic tiles means this border is one of the easiest to make. Its abstract nature also makes it a good choice when mixing lots of different colors. The original uses classic colors—ocher, black, and white—but a jazzy version could contrast acid yellow and pink with warm terra cotta and dense black and purple. In the second variation a range of blues and white have been put together to produce a clean, fresh approach.

VARIATIONS

1

2

Key Border

Although a classic Roman mosaic design, this kind of border is more often described as a Greek key or fret design. The original uses the classic color combination of earthy red, black, and white, but such a design can be brightened up by injecting some vibrant colors, such as the blue, mauve, and lime green in the first variation, or the red and orange, offset with dark green and gray, of the second colorway.

VARIATIONS

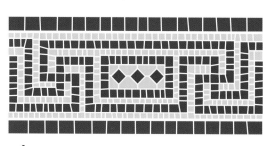

1 | 2

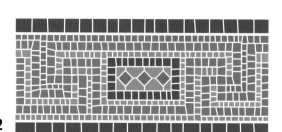

1

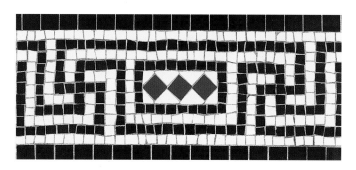

2

Natural Floral Border

The flowers in this border mosaic look like they are being blown around by the wind. It is not only the strong background curves, but also the crazy colors that give this pattern plenty of energy. The hues of the flowers appear all the more intense because they are isolated. The first variation maintains the bright flowers but sets them against a dark background, whereas the second utilizes a narrower range of colors, the greatest contrast being the dark blue flowers against the light green background.

VARIATIONS

1 | 2

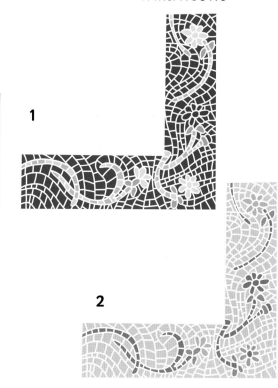

1

2

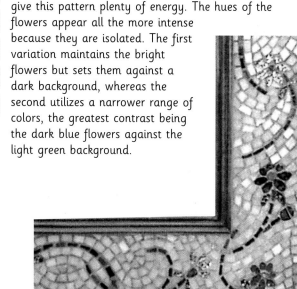

Leafy Border

Images from the natural world can be used to build up patterns, as in this leafy border mosaic. The leaves are set at lively angles against a regular background, and the berries, set at intervals and with their bright hue, increase the interest. The first variation experiments with increasing the tonal differences in the pattern, particularly between the leaves and the background. The second keeps it all on a more even keel by using closely related colors.

VARIATIONS

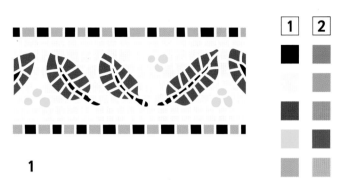

1

2

Flower Border

This border mosaic is based on a busy little row of flowers. The idea is simple, but the many colors ensure that there is a lot going on in this design to interest the eye. The alternation of types of flower provides some consistency, as does the solidity of the background pattern, opus tessellatum. One variation replaces the primary colors of the original with a palette based on secondary colors, shades of purple and green, while the other alternative makes use of a greater tonal contrast.

VARIATIONS

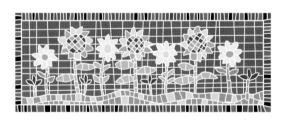

1

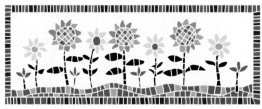

2

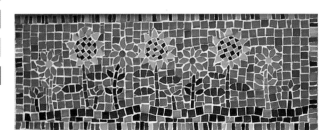

Roman Twist Border

A broad and opulent twist border mosaic is formed using classic colors in the Roman tradition that contrast dark, light, and mid-tones. The curving lines that make up this border are smooth and even. The second color variation uses a darker palette with warm, earthy shades, whereas the first throws tradition out of the window with brighter, more intense hues that the Romans would not have had access to.

VARIATIONS

1

2

1 2

Decorative Letter N

Using a letter as a branch for a lizard to sit on is fun and effective. It is important to remember that the letter itself should be sharp and clear so that we can still make visual sense of it, even though the organic lines of the lizard are draped over it. In contrast to the subtle hues used in the original, both variations utilize bold hues for the letter that complement, yet also stand out from, the coloring of the lizard.

VARIATIONS

1

2

1 2

Number 8

The success of this house number mosaic lies in the confidence and simplicity with which it has been made. The orange contrasts well with the blue background and the whole effect is bolstered by the choice of dark grout. The varied tones in the background enrich the whole motif. Note how the tesserae that compose the figure are long and thin, as is the outer rim of the background, whereas the remainder of the background uses smaller squares. The two variations go for a greater tonal contrast, but one places a dark figure on a light background, while the other does the opposite.

VARIATIONS

1

2

Numbers 2 and 5

These numbers are good and clear in a lovely rich red that stands out well against the beige background. The beige works against the black and white border because, being a mid-tone, it stands out from both the dark and the light tesserae. The odd silver pieces add a note of sophistication. The two alternatives employ a more varied use of color, and experiment with the tonal play between background and border.

VARIATIONS

1

2

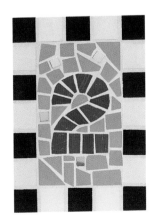

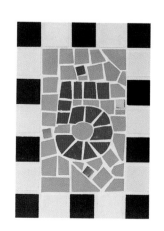

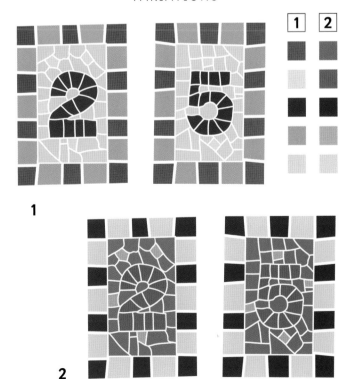

FOOD FOR THOUGHT

Food and drink give us life and this provides a wonderfully celebrative subject for a mosaic. The "unswept floor" technique involves building a floor mosaic and incorporating into it the strewn remnants of a feast: chicken and fish bones, lobster claws, nutshells, and occasional cherries. This theme may appeal to you if you have ever gained a certain pleasure from wandering around the remains of a really good dinner party the morning after: the chaos and debris speak so eloquently of a good time had by all, and the memories are worth the knowledge that it all has to be cleared up. Images of food and drink, therefore, can remind us of the people we share it with.

Ears or sheaves of corn often appear in early mosaics, symbolic of harvest, fruitfulness, and the Body of Christ. Fruit—particularly grapes—and wine appear frequently as well, and Byzantine mosaics featured the loaves and fishes of the Bible. Fruit provides much scope for decorative motifs in mosaic: lovely rounded shapes, varied colors, and interesting patterns can be exploited when the fruit is cut open. A memorable modern day motif I once came across was a mosaic "school dinner," made by a primary school child: sausage, egg, and peas on an oval plate with a knife and fork.

Plate of Fruit

Seeing fruit reflected in a silver salver was the inspiration behind this mosaic. The tray is built up using different colored gold smalti (red, yellow, and white) to reflect the bright colors of the oranges and lemon. In the first alternative, one of the oranges has turned into a green apple, and the orange, yellow, and green fruits are set onto a mauve plate; a colorful mixture that makes use of a few complementary colors for good measure—orange and green, purple and yellow. For the second colorway, the brilliant hues have been abandoned, replaced instead with earthier tones. The oranges have become russet apples and the lemon has turned into a lime.

VARIATIONS

1

2

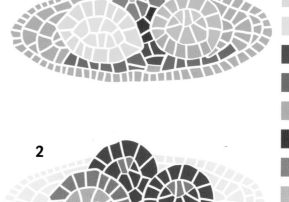

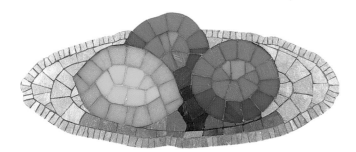

Bowl of Apples

The restrained colors of this mosaic produce a calm atmosphere. The curve of the bowl is indicated by the gentle sweep of the rows of tesserae. Note the combination of cool greens and warm greens, which gives the fruit interest. The palest green is used at the top of the apples, where they would naturally catch the light from above. The same principles are used in the variations, but the colors themselves are very different. The bowl can be striped or patterned instead of plain.

VARIATIONS

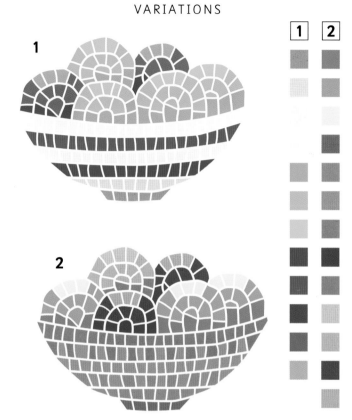

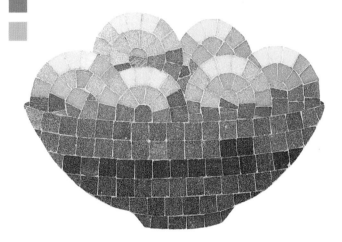

Cut Lemon

Cross sections of fruit have great decorative potential. Here, the direction of the tesserae, flowing outward from the center, successfully mimics the flesh of the segments. While natural lemon colors are used in the original, the first alternative combines lime greens with a black outline that indulges the abstract quality of the image. The second variation uses a subtler mix of shades.

VARIATIONS

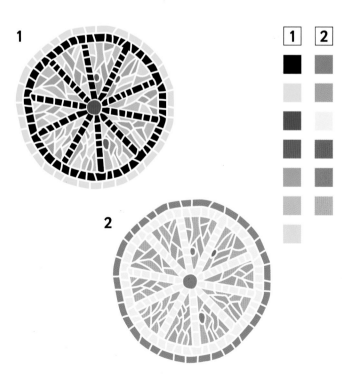

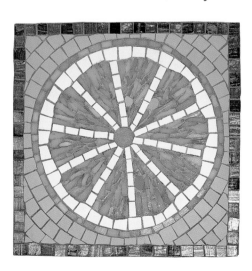

Cut Apple

Pale creamy colors are used for the flesh of this apple and contrast well with the black pips and green peel. The dark rim acts as a frame for the delicate interior, and the curved andamento accentuates the fruit's rounded form. Both alternatives retain this formula, although the variety of apple can easily be changed to a Red Delicious or a Russet.

VARIATIONS

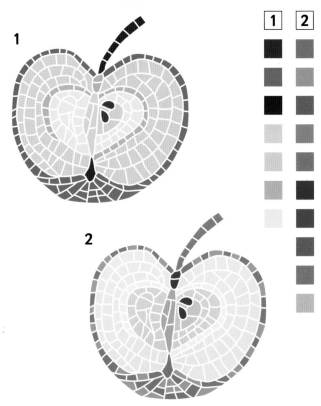

1

2

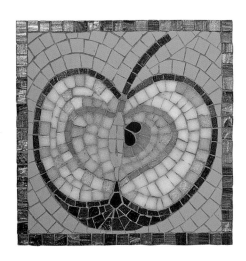

Watermelon

With its ripe pink flesh and individually cut black seeds, this generous slab of watermelon is simple but decorative. The lines of tesserae making up the rind curve around the center, enclosing the horizontal rows of opus tesselatum that march across, broken by the tiny pips. The variations suggest a less ripe melon, with delicate pink flesh that emphasizes the black pips, and a pale green melon with golden seeds.

VARIATIONS

1

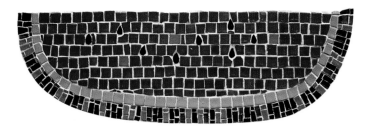

2

Pineapple

The spiky leaves and full, rounded shape of this pineapple mosaic are very convincing, and the use of turned, square tesserae is particularly successful in building up the diagonal pattern of the skin. The first suggested variation uses bright, jazzy hues that are purely decorative, while the other has a toned down approach that is more in keeping with the original.

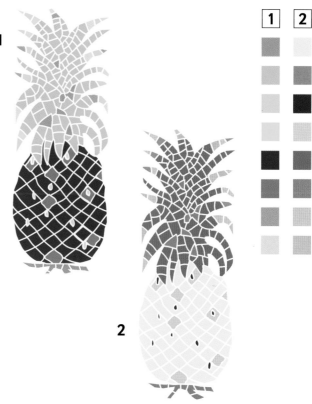

Pear

An imaginative variety of colors is combined in this mosaic to produce a characterful piece of fruit. Note how the single tile outline creates a strong contour defining the beautiful pear shape, while the interior tesserae fill the space with a kind of organized chaos. The pattern, opus palladianum, is directionless in itself but the colors work their way across the pear to create a definite progression: from the orangey-reds on the one side to the light blues and greens on the other. The variations suggest an unripe pear in shades of green, and a russet one.

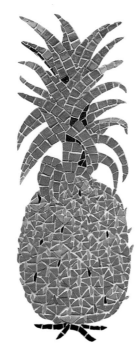

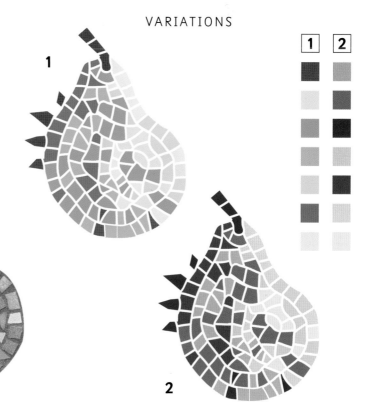

Bunch of Grapes

Light appears to be falling from above onto this bunch of grapes, because each mosaic grape is tonally graded to imply this. The bunch as a whole becomes darker at the bottom where there is less light. Naturally, grapes are found in some wonderful colors, and the variations suggest a green and a rich purple bunch. The color of the stems provides a contrast in each case.

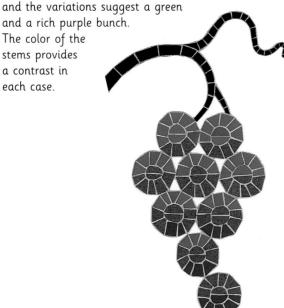

VARIATIONS

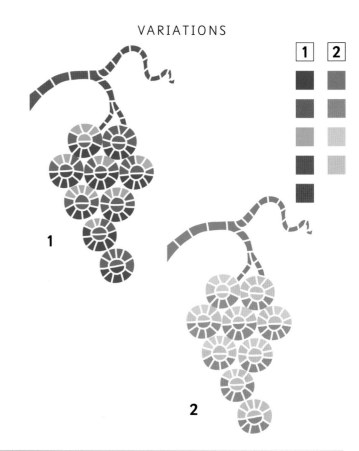

Cherries

These cherries were made using wedge-shaped tesserae that fit perfectly together to describe the round forms. The light strikes them from above, so the tesserae become darker by degrees from the top down. The outline of the leaf is formed by smooth lines of tesserae to emphasize a lilting movement. The red cherries balance tonally with the leaves, while the black stems add some sharp interest. The variations show rich, dark purple cherries and a lighter yellow variety.

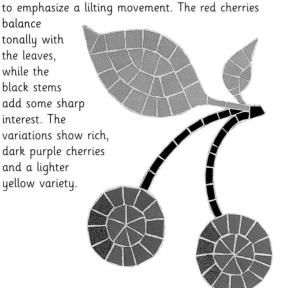

VARIATIONS

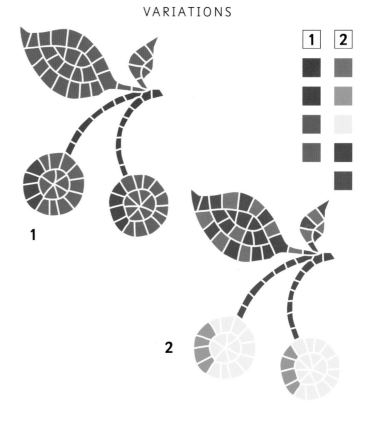

Cut Bell Pepper

Everyday objects can provide good design sources for mosaics, as this cut pepper illustrates. Peppers are naturally available in several colors, like the red of the original, and the yellow and green alternatives. The bright yellow variation has an unnaturally blue stem that contrasts with the hot oranges and yellows and sharpens up the mosaic. In each case, the andamento is used to describe the curves of the pepper shape.

VARIATIONS

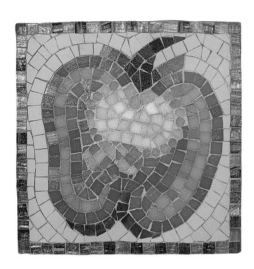

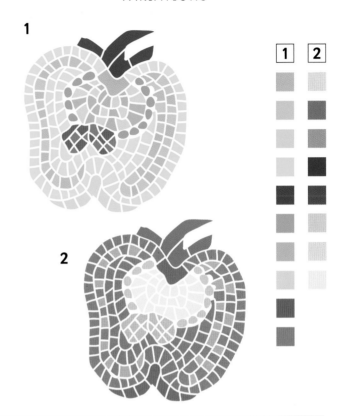

Mushroom

This mushroom is simply conceived in a graphic but effective way with the decorative gills and the slight bend in the stalk. The black linear tesserae are reminiscent of running stitch, as if the mushroom has been quilted or embroidered. The two variations make more use of color: one masquerading as a toadstool from a fairy tale, and the other in gentle brown and pink, naturalistic shades.

VARIATIONS

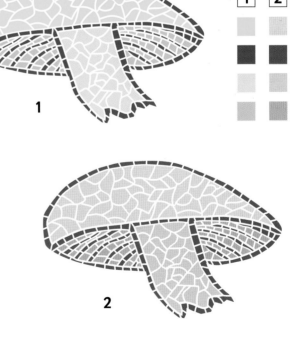

ECLECTIC CREATIONS

One of the best aspects of the mosaic art is the sheer breadth of scope it offers the creative mind. The following pages show that almost anything can provide inspiration. From domestic objects like teapots and candlesticks, technological innovations from motorbikes and cars, a dream-like hot-air balloon, moving and expressive portraits, and musical instruments with beautiful and sinuous curves, all have inspired individual artists to recreate an image in their mosaics, constructed in a variety of ways. Some motifs thrive on an instinctive approach, where the tesserae are placed almost intuitively. Others are carefully planned and the tesserae are shaped individually and with precision. There is no right or wrong way: it is part of each mosaicist's unique approach to the subject.

Just as earlier cultures put the things that were important in their lives into their mosaics—whether it was domestic artifacts from the home, hunting parties, or the gods they worshipped—that tell us a little about their lives, so are we unwittingly doing the same. If only it could work in reverse: what would those early mosaicists have made of our motorbikes and hot-air balloons? And what will future generations make of it all?

Turkish Houses

Simple but strong, this Turkish-style motif has a charm reminiscent of folk art. Both the construction and the coloring are bold. The mosaic makes excellent use of black grout, which helps to create a sense of the design having been confidently drawn by a guileless hand. Apart from the black and white detail, the tesserae are fairly similar in tone, a factor retained in the variations, one carried out in light colors with dark windows, and the other in warmer tones.

VARIATIONS

Candlestick

Warm shades of gold smalti (which are not always easy to cut) make up this majestic mosaic candlestick. The monolithic design demands a strong, solid treatment, so the two suggested variations are kept simple and bold in their composition. The blue candlestick contrasts nicely with the gold one.

VARIATIONS

1

2

Coil Clock

This lovely decorative clock resembles a cross between a dartboard and an ammonite. Notice how the tesserae spiraling out from the center gradate from one to two to three rows. This is effectively disguised by the dramatic alterations of tone. The overall effect is bold and striking. Suggested variations could utilize a more acid palette, or use a mix of warmer colors.

VARIATIONS

1

2

Teapot

Immortalized in this mosaic is a much used and loved teapot that was treasured for its beautiful shape, but eventually broke through pure wear and tear. The gentle curves of the andamento caress its shape, and the soft gradation of several tones give the effect of filling out the rounded body. Alternative variations should take care to reproduce the curves in the same way, but could use fresh blues and whites, or be based on shades of warm green.

VARIATIONS

1

2

Gold-edged Teapot

Curving lines of tesserae beautifully describe the teapot's form, while the patterned tesserae poignantly reincarnate broken domestic china to form, pictorially, another domestic artifact. The use of gold smalti on the rims adds a touch of class to this piece of crockery. One variation has muted pinks and yellows, with a deep red to add definition, while the other is much brighter in oranges and blues.

VARIATIONS

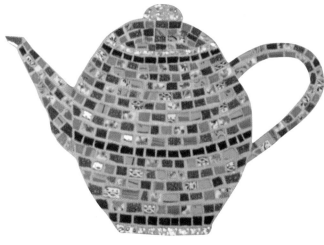

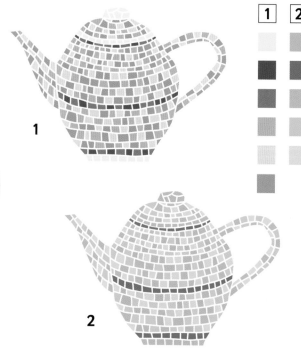

1

2

Coffee Pot

There is a pleasing juxtaposition in this coffee pot mosaic, with the twirly, skinny handle against the full, rounded body of the pot itself. The lines of tesserae in the main body and handle run vertically. In every other part they run more horizontally. The blue and green are very similar colors, but tonally the darker blue fortifies the detail. The first variation mixes two similar colors on the body, but the spout, handle, and details are picked out in a contrasting deep red. The second alternative tonally grades its colors up the body of the pot.

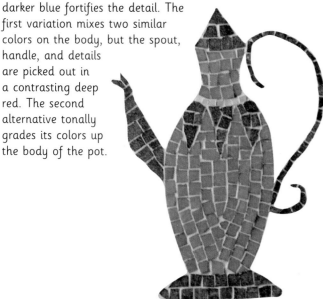

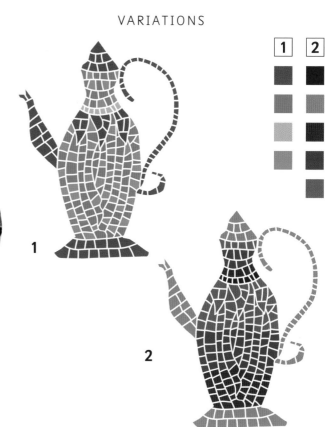

1

2

Cup and Saucer

The use of gold tesserae and patterned china has turned this everyday item into something more exotic. The rim is strongly described through both the gold smalti and the darker lines of tesserae. The variations are calmer versions: gentle blues with a dash of pink in one, and another that employs blacks and grays, with a white trim.

1

2

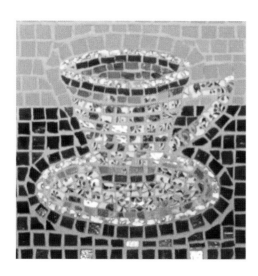

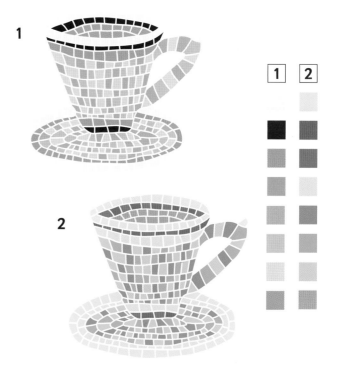

Vintage Automobile

Vintage automobiles make novel mosaic motifs, although the real things were probably never produced in quite the same color schemes. Earthy red, black, and gray combine to produce a subtle look, while a "look at me" bright yellow could also be used. A more restrained look uses classy greens. If you enjoy detailed work, then this is for you. You might decide to put someone in the car instead of leaving it driverless.

VARIATIONS

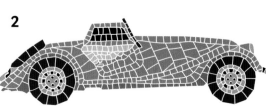

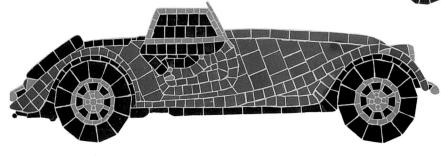

Bicycle

A mosaic of an old-fashioned bicycle can be composed of lines of tesserae, and is easier to construct than it looks. Using muted shades will create an authentic, traditional look, although bright blues and golden yellow make good alternatives. In each case, make sure the wheels are not as bright as the bicycle frame to give the motif the necessary sense of balance. For added interest, alternate the shades of color used for the spokes of the wheels.

VARIATIONS

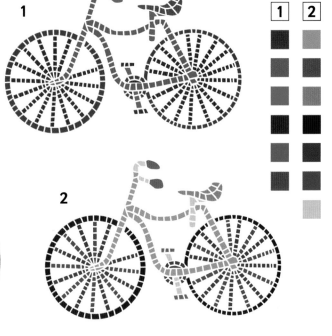

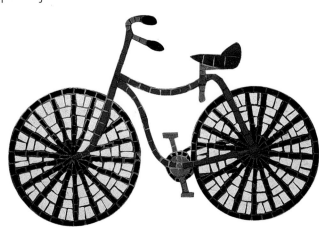

Vintage Motorbike

Reproducing this vintage motorbike is not for the faint-hearted mosaicist as many of the tesserae are individually shaped; nevertheless it is a very satisfying achievement. This mosaic has been built up in colors that approximate to the real thing, but there is no reason not to try some bolder colors, such as the blues and reds demonstrated in the variations.

VARIATIONS

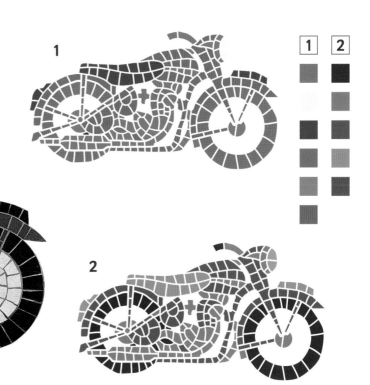

Hot-Air Balloon

This balloon motif is simple, but has a lot going on in it, and the result is curiously satisfying. Whole and quarter vitreous glass tesserae have been used. Yellow and mauve are opposing hues, and so sizzle together, but the effect is then made richer by the inclusion of closely related tones.

The three bold red squares add strength to the overall scheme. The suggested variations maintain the mood, both combining bright colors to produce a similarly festive effect.

VARIATIONS

Narrow Boat

Despite initial appearances, this motif is not difficult to construct, since it does not contain too many curves or awkward corners. The fresh, nautical colors used on the original can be changed to something a little more sophisticated by mingling closely related colors on the hull. Possible variations could combine shades of blue-green and lilac, or use warm browns, reds, and yellows.

VARIATIONS

1

2

Greek Boat

This boat mosaic has the ring of a traditional style of Greek art. The limited palette of earthy colors reinforces this effect. The tesserae on the boat flow horizontally to echo its shape; but within the rectangular frame of the sail, they work diagonally, facilitating the thin criss-cross pattern. The variations also avoid too diverse a palette, leaving the viewer to focus on the design.

VARIATIONS

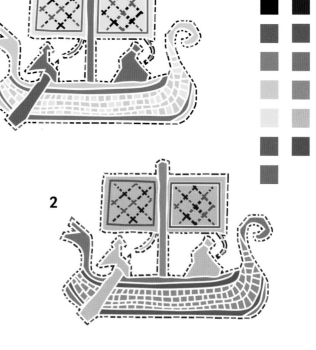

1

2

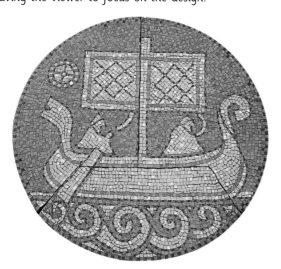

Train

■ This train motif has all the charm of an illustration from a children's book: the train bounces happily along over hills and valleys under a blue sky and in bright sunshine. The colors are well balanced, with the warmer yellow, red, and green dispersed over a cool blue background. The use of smaller tesserae around the train creates a small, busy patch. One variation has the train in muted tones; the other uses brighter colors.

VARIATIONS

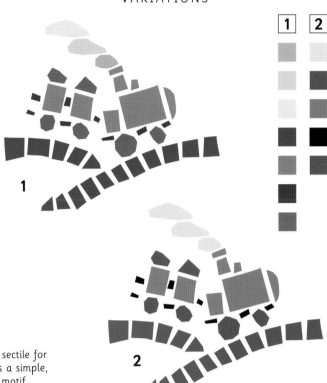

1

2

The use of opus sectile for the train, creates a simple, but well-defined motif.

Large pieces of tesserae create a bold surround that doubles up as a sky background.

Green tesserae placed in rows resemble both train tracks and green grass simultaneously; another clever, double use of tesserae.

Man's Head

There is a medieval air about this head mosaic. Although the design does not attempt to imitate a realistic face, it is expressive nonetheless. The bold outline is important and is therefore retained in the alternative versions, as is the way the face is broken up into blocks of color. This overall style does not suit a naturalistic approach, or an over-complicated or modern color palette.

VARIATIONS

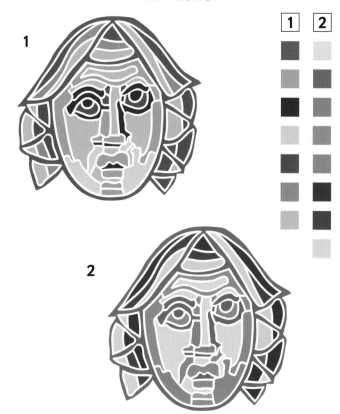

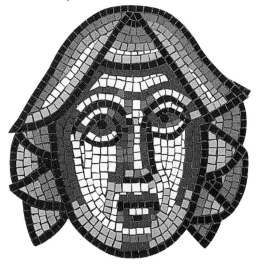

Woman's Head

The black lines that describe the features in this head mosaic impart a strength of character. The mingling of the flesh tones is carefully done and the effect is subtle and interesting. The first alternative colorway has a slight Gauguin feel to it with its use of secondary colors. The second colorway contrasts creamy skin tones with red hair.

VARIATIONS

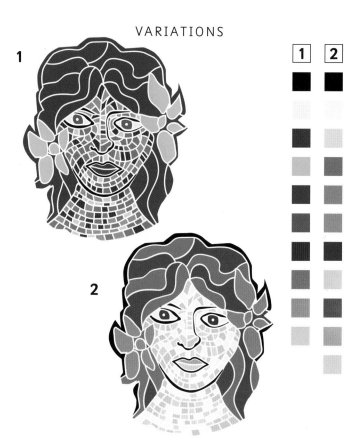

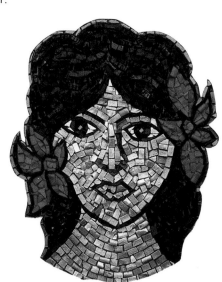

Clown

This clown has a marvelous leaning stance, most important to the character of the motif. The colors used combine dark, light, and bright hues with confidence and vigor. The tesserae follow the direction of the area they cover; this is most noticeable in the jacket "skirt," where they flow out diagonally. The hair is fun, made from lots of mini lozenges. One variation uses bright, pure hues, and the other strong, earthy colors.

VARIATIONS

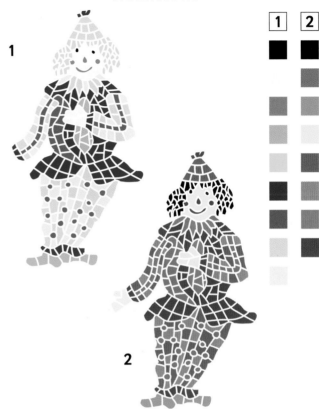

Washerwoman

This motif of a washerwoman is charming and quirky. It is made from large tesserae, and has a sense of spontaneity and immediacy about it. Each tessera works hard; for example, one for the whole forearm, and one for the entire face. Notice how the horizontal rows of tesserae in the skirt of the dress give it a slightly flounced look. The dark colors used make this particular mosaic reliant on silhouette, with one or two brighter colors to add interest. The first variation brings more contrast between the dress and the skin tones, whereas the second one mixes colors on the dress and in the basket to add a little texture.

VARIATIONS

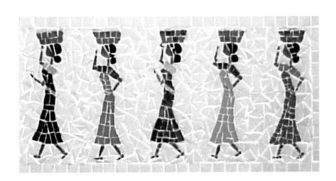

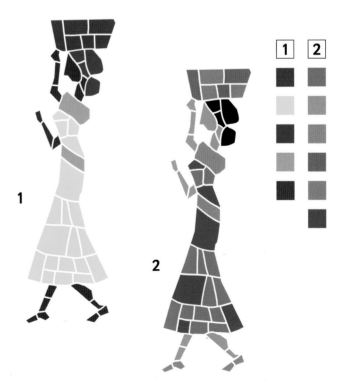

Guitar

The shape of this guitar is expressed by the curves of the outermost line of tesserae. Note also how the frets and strings are delineated not by the tesserae themselves but by their interstices. Possible color variations include using light "wood" shades, or cool blue with brown. In each case the neck should be kept darker than the body to strengthen the image.

VARIATIONS

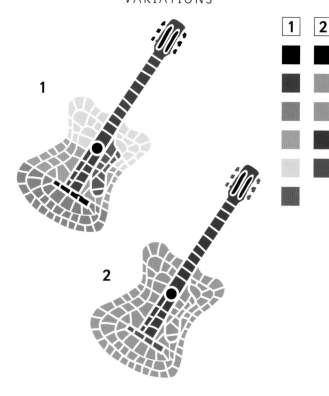

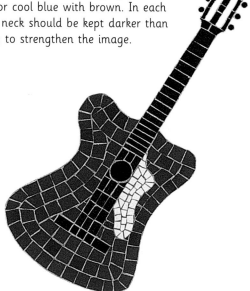

Saxophone

This saxophone has a marvelous abstract quality to it, and is full of movement. The little strip of orange, indicating the mouth of the saxophone, and the blue buttons add a welcome garnish to the solid color of the saxophone itself. One variation has used bright, jazzy hues to resemble a polished brass instrument; the other employs more muted tones. Both indulge the abstract quality of the mosaic.

VARIATIONS

Cello

In this mosaic the lines of tesserae beautifully complement the cello's curved form, and the strings are indicated by the gaps between the tesserae. These interstices are wider than in the rest of the mosaic to make a feature of the strings. The coloring is rich but simple; the tesserae are black or mid-toned, while the grout is pale, creating a well-balanced and, in the original, very realistic piece. In the first variation shades of brown are graded across the body of the instrument, while in the second colorway two tones of a single color are mixed together to add a little texture.

VARIATIONS

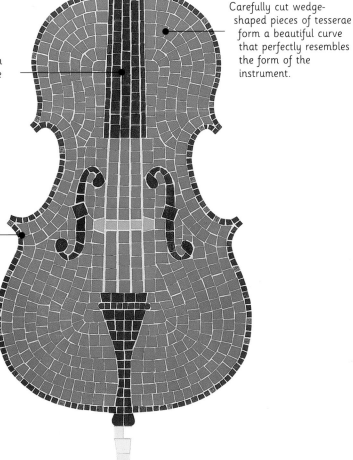

Simple stripes of alternating colors give the effect of complex scroll work.

Carefully cut wedge-shaped pieces of tesserae form a beautiful curve that perfectly resembles the form of the instrument.

Good use of the gaps between the lines of tesserae create the thin strings.

The slight variation of color in this outer line of tesserae adds definition and extra interest.

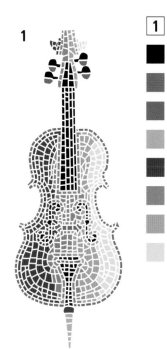

1

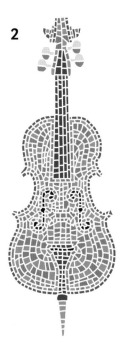

2

Bell

Excellent use of tesserae is the key to the success of this mosaic—the neat rim and the round bell and tip add a sense of formality to the crazy paving (opus palladianum) of the bell itself, even though the rim of the bell makes a sudden and unexpected color change from deep red to mauve. The overall feeling is one of movement, as though it is being rung. The variations maintain this slightly quirky feel by employing similar color changes.

VARIATIONS

1

2

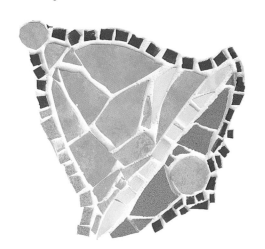

Umbrella

The small tesserae used in the circular background to this umbrella are a good device for giving the impression of rain. The sections of umbrella are opus palladianum: a busy pattern that flows out from the tip, and around it are curving lines of tesserae. One variation uses fresh pink, yellow, and a rich, warm brown, while the other employs more subdued tones of green, brown, and pink.

VARIATIONS

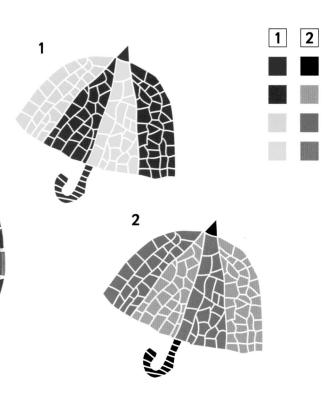

Eye

This startling eye is similar to the famous motif for the novel and film A Clockwork Orange, or those wonderful eyes from Ancient Egyptian art. The eye has deep tonal contrasts between the pale cornea and background and the dramatic eye rim, lashes, iris, and pupil. The dark corner pieces help to balance out the composition as a whole. The two variations maintain the intensity: one in deep purples and pale greens, the other employing more muted greens and browns.

VARIATIONS

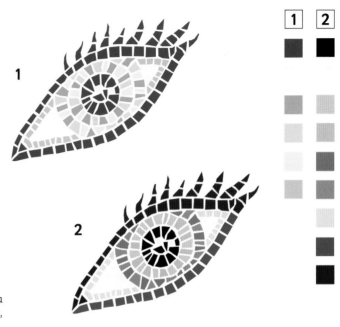

Although only a few tesseare have been used for the lashes, their individual shapes create a lot of movement and thickness, as if mascara is being worn.

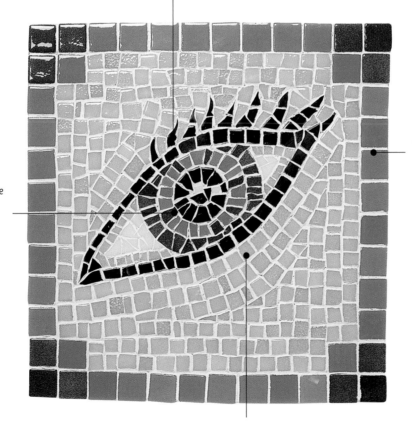

The use of the same colors in the border as employed in the iris makes the eye motif itself bolder.

Flecks of darker blue in the first row of iris tesserae soften the color change between the two rows of tesserae used for this section of the eye.

The skin-colored background tesserae in opus musivum emphasize the hyper-reality of this motif.

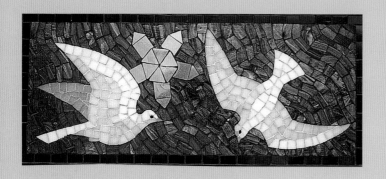

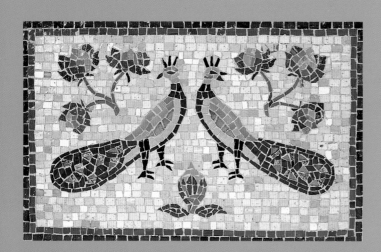

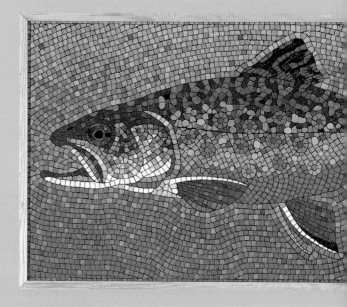

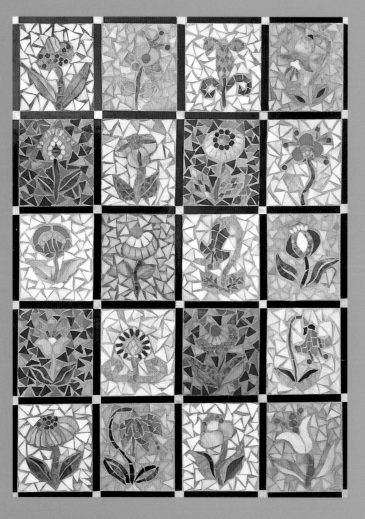

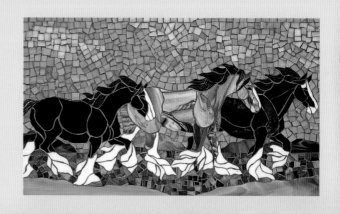

ARTISTS' GALLERY

Exceptionally fine pieces of work from several great mosaic artists are showcased here, illustrating how the mosaic medium can produce a dazzling array of different effects. Each artist has their own particular style—some work quickly and spontaneously, others are slow and careful; some work with delicate color schemes, others make a splash with strong, bold colors. There is no one way to make a successful mosaic, as each mosaicist uses his or her own creativity, originality, and artistry to produce a unique result.

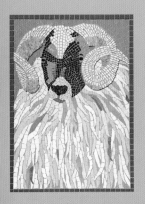

PRACTICAL MOSAICS

One of the marvelous qualities of mosaic is its sheer practicality. Tough and relatively vandal-proof, it is easy to clean and lasts for years, centuries even. Illustrated here are just a few of the uses mosaic can be put to.

Abstract fire screen
Jo Letchford

There is never a dull moment when looking at this mosaic fire screen as there are so many interesting things going on; the sunflower, the spiral, the snakes & ladders, the fish, all these interesting items are bound together by the border. There is also a generous distribution of circular, rectangular, and diagonal shapes and organic forms, while the blue background provides a note of consistency.

Geometric tabletop
Norma Vondee

The cool colors selected for this mosaic tabletop, combined with the innate hardwearing nature of mosaic tesserae, make this an ideal piece of patio furniture. The swirling design is reminiscent of early Celtic patterns. The dominating central design is the place to begin a mosaic like this, as the rest of the design will just flow out from here. By using the same colored tesserae as in the background, but placing them in a different direction, a coherent yet distinct border successfully frames the overall piece.

Floral table top
Mary-Kei McFallayne

Tabletops provide an excellent canvas for a mosaic. This particular example is full of movement and vigor, with a strong andamento in the blue background tesserae. The exotic flowers and dragonflies build up a dazzling color scheme against the dark frame and the curling tendrils, while the dark grout has a solidifying effect on the whole design.

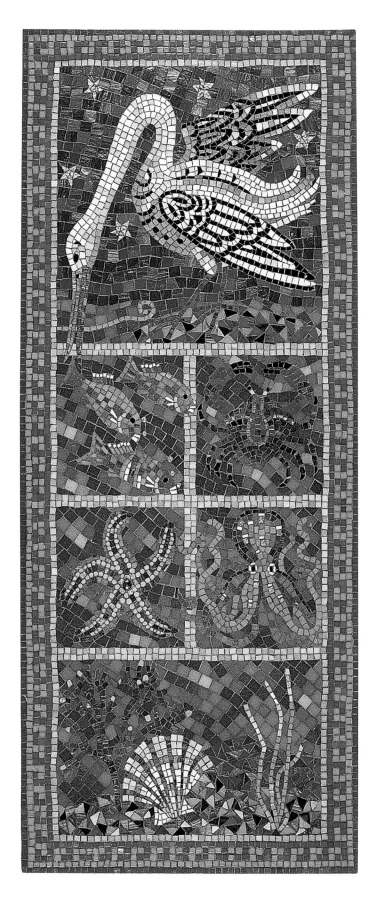

Candlesticks and Fruit
Rosalind Wates

A still life that is all about contrast. The warm, opaque orange against the cold silver; the cold yellow against the warm gold candlesticks; the deep purple against the complementary yellow; the dark birds against the pale snow; the interior against the exterior; and finally, human-controlled civilization against uncontrollable nature. The opus regulatum background provides a calm setting for the various, individually crafted objects.

ARTISTIC PANELS

Although mosaic is often set directly into a location, becoming an integral part of its surroundings, it can also be used as a medium for creating an independent work of art. The panels illustrated here can all be hung on a wall in the same way as a painting.

Marine life
M. Neville Smith

Virtually a visual directory of sealife, this panel is a rich resource of colorful motifs. The marine background colors provide a stable backdrop for the brighter motifs; it also contrasts well with the red and yellow border. The bird has been constructed in neutral tones to contrast with the strong colors used elsewhere. The starry night sky contributes to the air of mysterious exoticism.

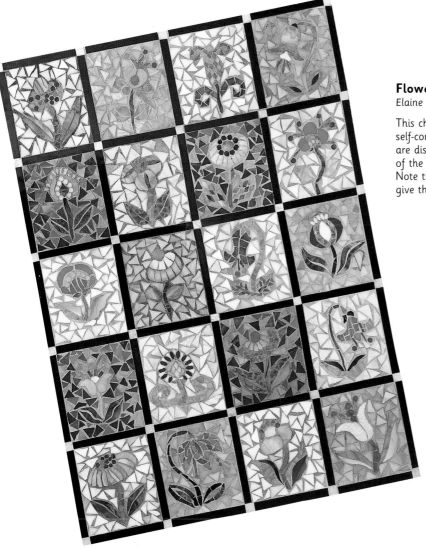

Flower Panel
Elaine Prunti

This charming panel turns each rectangle in the grid into a self-contained picture of a flower. The colors of the flowers are distributed informally enough to counteract the rigidity of the grid, and even the background blues and whites vary. Note the use of triangular tesserae in the backgrounds: they give the mosaic an individual character.

Yellow Room Triptych
Rosalind Wates

Each of the panels that make up this triptych works as an individual picture as well as part of the whole. With the interior broken up in this way each panel can also be read in a more abstract way. The main colors crop up in each section. Light and dark tones are contrasted, as are yellow with blue and murky with clear. The busy patterned areas are set next to calm, ordered spaces. The three panels resemble window panes; the viewer is looking in, and tendrils of ivy creep across the glass.

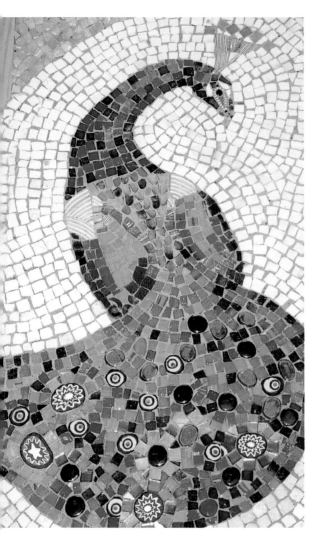

Peacock
Annie Kimber

The beautiful curve of this peacock's head as it glances sideways is echoed by the andamento of the surrounding tesserae. The tail is sweeping in the opposite direction, and thus creates the impression of a graceful "S". The peacock's tail displays exotic beads and glass gem-like pieces; ignoring the swirl of surrounding tesserae, these pieces gaze directly at the viewer. The dark blues of the head and the neck are balanced in the tail.

SHAPES & PATTERNS

Mosaic is a very decorative medium. There is a great deal of scope within the main compositional structure for creating expressive patterns and for sheer embellishment. The mosaics illustrated here revel in and exploit these possibilities in different ways.

Turkey
Annie Kimber

A mosaic turkey has had an almost iconic status conferred upon it by a glorious golden background. The strong colors used in the bird stand out well against the gold. Note how the curving background lines that follow around the head and the tail draw attention to and enhance these features. The delicate darkening of the gold where the turkey stands, like a shadow, adds depth.

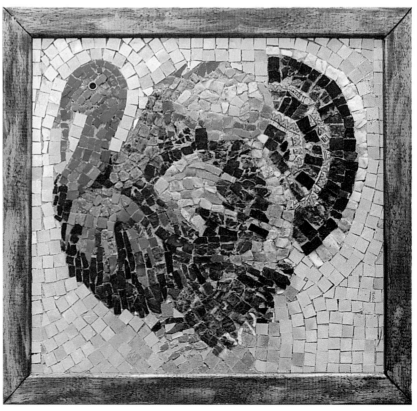

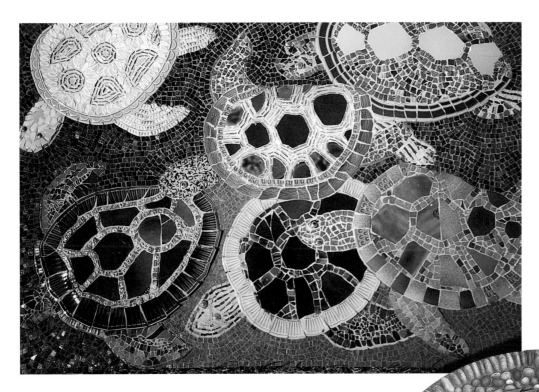

Turtles
Colette Brannigan

The various turtles in this mosaic illustrate a good use of tesserae of different sizes. Large pieces in the center of the shells are surrounded by slightly smaller pieces that make up the pattern. Smaller pieces still fill the gaps and medium-sized tesserae form the shell rims. Note the good use of the striated patterning in the ceramic, adding to the overall richness. The sea changes from dark to light, and so do the turtles, sometimes blending and sometimes contrasting in hue and tone. Fabulous.

Simurgh
Mark Davidson

A simurgh is a weird creature, a combination of peacock, lion, and griffin. It has Persian origins and contains magical healing properties. This ornamental panel is mostly made out of pebbles. Note the difference between the rounded pebbles set in the background and the decorative effect of the long thin ones set in rows. The tiny stones used for the eye and necklace add a pleasing detail and the overall colors are rich and natural.

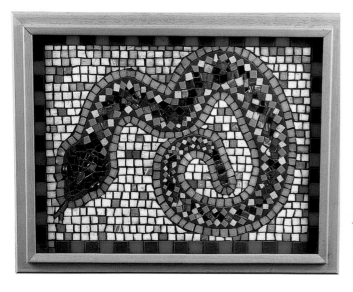

Snake
Kevin Grant

This fat snake curls to fit the picture frame very satisfactorily. Apart from the white and black tesserae, the colors are muted but vary in warmth and tone: light blues, gentle mauves, and understated orange. The smooth outline of the snake contrasts not only with the diamond pattern within, but also with the opus tessellatum of the background. The dark grout adds strength to the mosaic.

ANIMAL FARM

Animals are a favorite subject of mosaicists; their beautiful shapes and their potential for flow and movement often press emotive buttons in out psyche. They also provide great opportunities for color variations and for a range of mosaics from the most simple to the highly complex.

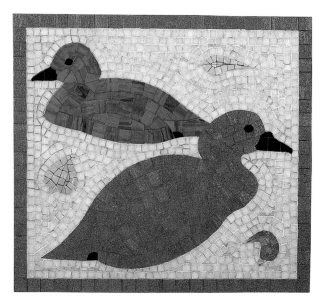

Ducks
Rosalind Wates

In this mosaic, a pair of ducks drift quietly on the water, a few leaves floating by. The lines of background tesserae—opus musivum—imitate water being disturbed by the bird's presence, and also echo their shapes. The ducks are made prominent by the use of dark, rich colors and larger tesserae, against the more delicate background of light blue and gold.

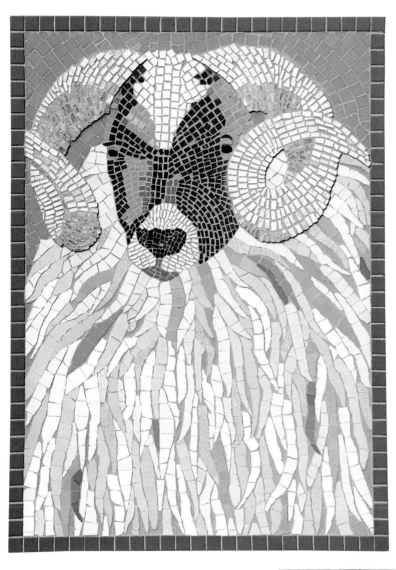

Ram
Caryl Paterson

This mosaic employs different scales of tesserae to express different parts of the sheep. Note how the small tesserae easily follow the curve of the horns, while larger tesserae have been used to form the shaggy fleece. The ram is composed of mainly neutral shades, with the odd flash of red and yellow; the strong colors of the background compensate for this, strengthening the whole panel.

Dog
Rosalind Wates

This mosaic contrasts the leaping vitality of the dog with an ordered geometric background—opus regulatum. The energy of the dog is expressed in its silhouette, which conveys all the necessary information. The animal is frozen in time, gilded to celebrate the moment. A contradiction of stillness and movement, and a journey from darkness into light.

Shire Horses
Judy Wood

In this piece, a curious but successful juxtaposition between two different mosaic styles is illustrated. First, there are the carefully planned and cut-out pieces that make up the horses and show off their anatomy—opus sectile—contrasted with the informality of the pattern of the tesserae in the sky that produces a lot of movement: it's a windy day. The horses' manes and the hair on their great hooves are being blown about too. The three horses are well matched tonally; from black to gray, to reddish tones.

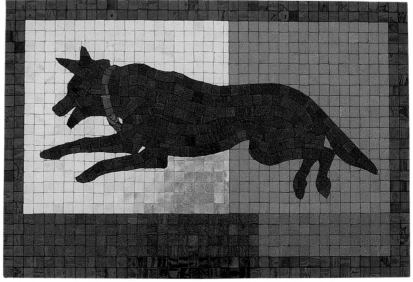

EXOTIC INFLUENCES

Whereas some mosaics are influenced by objects close to home, others are inspired by myths and cultures from afar. Ancient cultures continue to fascinate us, and provide rich and varied sources of design material.

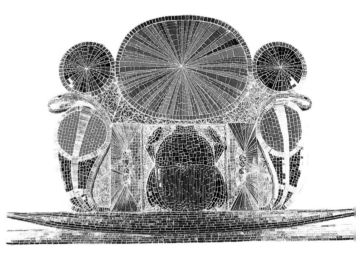

African Sculpture

This wooden sculpture is from Ghana, and its mosaic decoration shows how widespread the medium is. The tesserae are mostly tiny beads, with copper triangles set around the rim. The grout, or non-mosaic area plays a fundamental part in the whole: the extensive dark area surrounding the motif emphasizes its jewel-like quality.

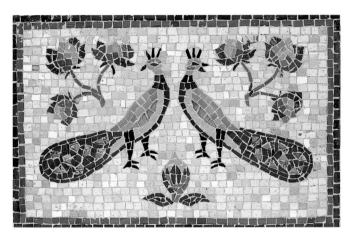

Peacocks and Flowers
Anna Wyner

The motifs in this panel (traditional flowers and birds) are well balanced, and the quiet pinks and creams make a charming background. The blues and greens of the foliage and birds stand out well, and the sharp cerise of the flowers provides an interesting contrast with the soft, warm pinks around them. The dark reds of the border contain the composition well.

The Favorite Mare
Judy Wood

This mosaic has been inspired by traditional Native American culture. The horse and its rider have been created in opus sectile, and are set against a more informal, patterned background. Interestingly, the motif extends beyond the circle in which it is set; a deliberate decision that goes against the ancient tradition of fitting, and sometimes distorting, the motif within the medallion. The colors are bright and lively within the circle, but lighter and more tranquil in the surround.

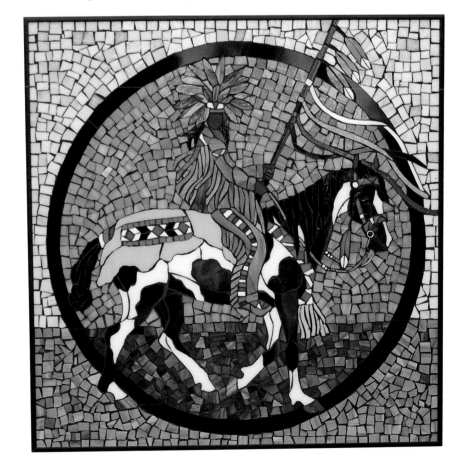

Egyptian Plaques: Scarab and Eye of Horus

Rebecca Newnham

These wall reliefs take ancient Egyptian motifs and symbols and treat them in a very modern way. The grout lines between the tesserae are particularly important in these mosaics; note the radiating patterns on the circles and oval-shaped sun motifs, and the long, thin lines on the folded wings of the scarab. The gold areas contain a variety of different patterns; this is an intricate and sophisticated treatment of potentially overwhelming amounts of gold. The red and blue areas, too, vary tonally. The scarab is apparently rolling the sun across the heavens as the dung beetle rolls egg-filled balls of dung around; this symbolizes regeneration. The Eye of Horus, the left or lunar eye of the sky god Horus, symbolizes the importance of light, strength, and power. The lotus flowers that make up the border underneath are sacred to Horus and stand for creation and immortality.

STUDYING NATURE

The mosaics selected for this section show the advantages of closely studying the subject on which a motif is based. Each mosaic carefully analyzes the essence of the source material, yet, by celebrating it, lifts it into another realm. In some cases a fantasy world is created.

Fish
Zantium

There are so many good things going on in this mosaic, that it is difficult to know where to start! For example, the mutation from dull colors on the back to brilliant hues on the belly gives the fish a molded effect. This also corresponds with what is happening with the water: lighter where the dark fish back is, for a tonal contrast (the back is slightly yellowish against the blue, as well), and a deeper blue to compete with the bright red and the white streaks lower down. The background outline gives the fish great clarity. Also, the blue of the dots on the fish's body plays a trick on the eye, creating a slight camouflage effect, as if the fish is a little transparent.

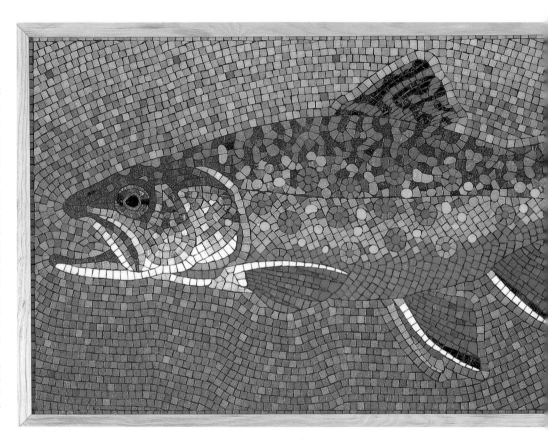

Deer
Stewart Hale

A strange, dream-like quality is immediately apparent in this mosaic. The colors that make up the deer are a similar blend to the background: a combination of pastels, bronzes, and a few darker colors to give it an edge. The deer seems to blend in with its backgound, but intriguingly its front hoof is in front of the strangely patterned ribbon that drifts across the lower part of the mosaic. The andamento constantly changes direction, giving movement to the whole composition.

Puffin
Lia Catalano

A marine-colored background sets the scene for this characterful seabird. The background tesserae have been delicately gradated to a lighter tone around the puffin's body, where they are arranged into opus musivum to further emphasize the subject. The colors of the tesserae used for the puffin itself, perfectly match the real thing.

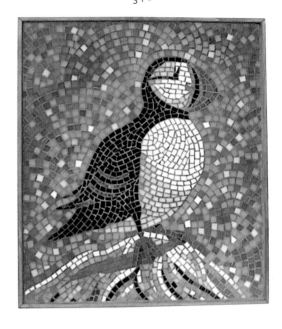

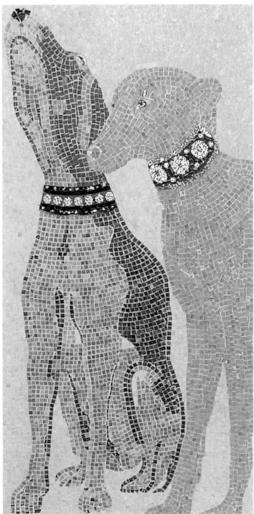

Two Dogs
Kathleen Stone Sorley

A marvelous use of mixed and muted shades of tesserae is what stands out about this mosaic. The dogs appear as if in a dream, or as ghostly apparitions, due to the similarity of tone and color between the dogs and the background. The andamento is used in an expressive way: it flows across the chest and neck of the dogs giving a sense of solidity, but moves upward under the chins, which are softer and more vulnerable. The sparkling, jeweled collar details bring an extra element that adds to the mystique.

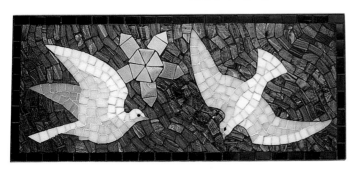

Two Doves
Rosalind Wates

The motifs in this mosaic have been carefully arranged to exploit the proportion of the frame. The lines of tesserae quietly and calmly follow the graceful forms of the doves, ignoring the hot, tempestuous lines that twist across the background. The grout has been tailored to match tonally the different parts of the picture: light on the doves and dark on the background.

Resource Directory

AUSTRALIA

Metric Tile
38–42 Westall Road
Springvale 3171
Victoria
Tel.: 03 9547 7633
Fax: 03 9547 3189
www.infotile.com.au/metrictiles/index.html

Di Lorenzo Ceramics
9 Penny Place
Arndell Park (Blacktown)
NSW 2148
Tel.: 02 9671 6388
Fax: 02 9671 6499
www.infotile.com.au/dilorenzo/index.html

CANADA

Interstyle Ceramic & Glass Ltd.
8051 Enterprise Street
Burnaby
B.C., V5A 1V5
Tel.: 604-21-229
Fax: 604-21-544
www.interstyle.bc.ca

U.K.

Edgar Udny & Co. Ltd.
The Mosaic Centre
314 Balham High Road
London SW17 7AA
Tel.: 020 8767 8181

Focus Ceramics
Unit 4 Hamm Moor Lane
Weybridge Trading Estate
Weybridge
Surrey KT15 2SD
Tel.: 01932 854881
Fax: 01932 851494
E-mail: focus@info.co.uk

Reed Harris Ltd.
Riverside House
Carnwath Road
London SW6 3HS
Tel.: 020 7736 7511
Fax: 020 7736 2988

Mosaic Shop
1A Princeton Street
London WC1R 4AX
Tel./Fax: 020 7404 9249

Mosaic Workshop
Unit B 443–449 Holloway Road
London N7 6LJ
Tel./Fax: 020 7263 2997
www.mosaicworkshop.com

Tower Ceramics
91 Parkway
Camden Town
London NW1 9PP
Tel.: 020 7251 6959

U.S.A.

Carter Glass Mosaic
910 S. Hohokam Drive
Suites 113/114
Tempe, AZ 85281
Tel.: 480-557-6336
Fax: 480-557-7049
www.carterglassmosaic.com

Mountaintop Mosaics
Elm Street
P.O. Box 653
Castleton, VT 05735
Toll-free: 800-564-4980
Fax: 802-468-2183

Norberry Tile
207 Second Avenue South
Seattle, WA 98104
Tel.: 206-343-9916
Fax: 206-343-9917
www.norberrytile.com

Pompei Mosaic Tile
11301 Olympic Boulevard
Suite 512
West Los Angeles, CA 90064
Tel.: 310-312-9893
Fax: 310-996-1929
www.pompei-mosaic.com

Tile Specialties
P.O. Box 807
High Springs, FL 32655
Tel.: 904-454-3700
Fax: 904-454-1844
www.tilespecialties.com

Wits End Mosaics
5224 West State Road 46
Suite 134
Sanford, FL 32771
Tel.: 407-32-9122
Fax: 407-322-8552
www.mosaic-witsend.com
E-mail: info@mosaic-witsend.com

Index

Credits

Quarto would like to thank and acknowledge the following for supplying pictures reproduced in this book.

b = bottom, t = top, c = center, l = left, r = right

Aimee Selby p55t. **Anna Wyner** p42t; p51b; p70t; p123t. **Annie Kimber** p118t&b. **Caryl Patterson @ Mostly Mosaics** p121tl. **Clare Sapwell** p39. **Colette Brannigan** p61b; p119t. **Craig Tockman @ Manzella Mosaics** p97b. **Del Palmer @ Cave Canem** p30b. **Donna Reeves** p32t. **Elaine Prunti @ Imago Mosaic** p53; p71b; p72t&b; p117t. **Emma Ropner** p100b; p101b. **Glen Morgan** p7tl; p40t; p57t. **Ilona Bryan** p33b; p59t; p65t; p69b. **Jane Muir** p45b. **Janet Kozacheck** p32b; p58; p82b. **Jeni Stewart-Smith** p21tr; p42b; p57b; p62t; p64. **Jessie Ong** p90t. **Jo Letchford** p29b; p63t&b; p93b; p94t; p97t; p114. **Joanna Buxton** p38t; p41t; p62b; p67b; p75b; p90b. **Judy Wood/Glasswood Studio** p36b; p120b; p123br. **Kathleen Stone Sorley** p125c. **Kevin Grant** p44b; p119bl. **Kirsty Shepherd** p111. **Lia Catalano @ Hannacrois Mosaics** p23t&cl; p38b; p40b; p43t; p48t&b; p55b; p59b; p67t; p70b; p85t; p88b; p125tr. **Marcelo Jose de Melo** p20tr; p91t. **Mark Davidson** p30t; p119cr. **Mary-Kei McFarlarne @ Mary-Kei Mosaics** p24b; p43b; p71t; p82t; p89t; p94b; p95t; p98b; p115b. **Melanie Charlesworth & Andy Cumper @ Mosaiko** p91b. **Melissa Neville Smith** p66b; p81b; p83t; p116l. **Michel Thevenot** p60b. **Mireille Lévesque @ L'Atelier du Fleuve** p35b. **Mosaico Arte ed Artigianato di Antonina Parisi** p79b. **Nicola Haslehurst** p44t; p51t; p60t; p76b; p79t. **Peter Massey @ Zantium** p25t; p34t; p37t&b; p54t; p61t; p66t; p99b (Alison Slater); p109; p115t; p124c. **Pippa Howes** p28b; p50; p73; p77; p83b; p85b; p105; p108b; p110t&b. **Raymond Gordon** p106b. **Rebecca Newnham** p20b; p74b; p122t&cr. **Robert Field** p31t; p33t; p35t; p36t; p106t. **Rosalind Wates** p7r; p29t; p31b; p41b; p46b; p47t&b; p52t&b; p54t; p56b; p68b; p69t; p74t; p78t; p80b; p86t&b; p87t&b; p88t; p92b; p93t; p96t&b; p99t; p100t; p102t&b; p103t; p104t; p108t; p116tr; p117b; p120tl; p121br; p125bl. **Sally Imbert** p75t; p78b; p95b. **Sheryl Wilson @ Rep-tile** p76t. **Stephen Charnock** p45t; p104b. **Stewart Hale** p103b; p124bl. **Terry Rudd** p7bl; p49. **Tessa Hankin @ Mosaics Workshop** p24t; p65b. **The Art Archive** p6tr&bl. **Vinitha John** p101t; p107t&b. **Wendy Davison** p81t; p84t&b. **Wladimir Naumez @ Mosaik** p34b.

Quarto would also like to thank the following for their assistance in sourcing the pictures: BAMA (British Association of Mosaic Artist), SAMA (The Society of American Mosaic Artists) and Mosaic Matters.

All other photographs and illustrations are the copyright of Quarto Publishing plc. While every effort has been made to credit contributors, Quarto would like to apologize should there have been any omissions or errors.

The author would like to thank her partner Chris Sykes for his continued support throughout this project.